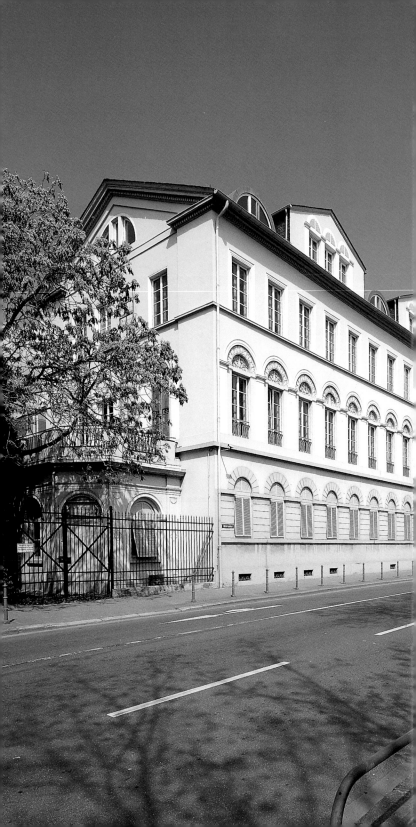

Jewish Museum
Frankfurt am Main

Prestel
Munich · Berlin · London · New York

© Jewish Museum Frankfurt am Main and Prestel Verlag, Munich·Berlin·London·New York, 2002

© for illustrations held by the artists or their estates, with the exception of works by Rudolf Belling held by VG Bild-Kunst Bonn and Ludwig Meidner held by the Jewish Museum Frankfurt am Main

Front cover: Frankfurt Passover Haggadah from 1731 (cf. p. 33), fol. 13a (detail)
Frontispiece: Exterior view of the Jewish Museum from the southwest (May 1997)
Back cover: Exterior view of the Jewish Museum from the Untermain Bridge (May 1997)

Plans: Thomas Sittig, for the Museum Judengasse based on the design by Feil + Hahn

Texts by: Georg Heuberger (GH), Annette Weber (AW), Michael Lenarz (MS), Johannes Wachten (JW), Helga Krohn (HK), Cilly Kugelmann (CK), and Fritz Backhaus (FB)

Editor: Johannes Wachten
Translated by Ishbel Flett

Die Deutsche Bibliothek – CIP-Einheitsaufnahme and the Library of Congress Cataloguing-in-Publication data is available

Prestel Verlag
Königinstrasse 9, 80539 Munich
Tel.: +49 (0)89/381709-0
Fax: +49 (0)89/381709-35;
4 Bloomsbury Place
London WC 1A 2QA
Tel.: +44 (0)20/7323-5004
Fax: +44 (0)20/7636-8004;
175 Fifth Avenue, Suite 402,
New York, NY 10010
Tel.: +1 212/995-2720
Fax: +1 212/9952733

www.prestel.com

Design: Matthias Hauer
Lithography: Repro Ludwig, Zell a. See
Printing and Binding: Passavia Druckerei GmbH, Passau

Printed in Germany on acid-free paper
ISBN 3-7913-2611-2

Jewish Museum Frankfurt am Main
Untermainkai 14–15
60311 Frankfurt am Main, Germany
Tel. +49 (0)69/212-35000
Fax +49 (0)69/212-30705

Museum Judengasse
Annexe of the Jewish Museum
Kurt-Schumacher-Strasse 10
60311 Frankfurt am Main, Germany
Tel. +49 (0)69/2977419

Opening hours
Daily (except Monday) from 10 a.m. to 5 p.m.
Wednesday late opening until 8 p.m.
Closed Monday

How to get to the Jewish Museum
Nearest tram and metro stop: Willy-Brandt-Platz
Tram line 11 and 12
Metro lines U1, U2, U3, U4, U5
Nearest car park: Parkhaus am Theater
Disabled parking: Hofstrasse 9

How to get to the Museum Judengasse
Nearest bus and tram stop: Börneplatz
Bus lines 30 and 36
Tram lines 11 and 12

Jewish Museum facilities (see also pp. 108–09)

Library
Tel. +49 (0)69/212-34856

Documentation and archives
Tel. +49 (0)69/212-38546

Ludwig Meidner Archive
Tel. +49 (0)69/212-38805

Buch-Café im Jüdischen Museum
Tel. +49 (0)69/234921

Guided tours
Guided tours for groups and school classes by appointment.
Tel. +49 (0)69/212-38804

This publication has been funded by the estate of Eva Brilling in memory of Professor Dr Bernhard Brilling.

STADT FRANKFURT AM MAIN

Contents

The Jewish Museum in Frankfurt am Main

The history of Frankfurt is inextricably linked with the history of the city's Jewish population. Even in medieval times, there were Jews living in Frankfurt, contributing towards all aspects of urban life. Before the Jewish community of Frankfurt was destroyed and its members murdered, it was the second largest in Germany, after Berlin. Given this fact, the history of the Jews in Frankfurt offers many insights into the historical development of the relationship between Jews and non-Jews.

The Jewish Museum of Frankfurt am Main, which was opened in 1988, is not restricted to presenting examples of decorative and applied arts, liturgical utensils and manuscripts, in the manner of its predecessor, the Museum of Jewish Antiquities which existed from 1922 until 1938. It is the intention of today's Jewish Museum that the exhibitions mounted here should promote the possibility of a dialogue for its predominantly non-Jewish visitors, elucidating the relationship between Jews and their environment against the background of the historical development in Frankfurt and highlighting the key elements of culture and religion, discrimination and animosity.

Three large exhibition areas are devoted to the historical development and religious culture of the Jewish communities in Frankfurt from the eleventh century to the eighteenth century and in the course of the nineteenth and twentieth centuries. A film on the history of the Jews in Frankfurt am Main is screened in the film room on the second floor, providing a succinct and informative introduction to the exhibitions. Regularly changing temporary exhibitions on the ground floor and second floor corridor serve to consolidate individual aspects of the permanent exhibition.

In the year 1992 the Jewish Museum gained an annexe at Börneplatz.

The main component of the Museum Judengasse is the excavation site showing the foundations of buildings in Frankfurt's former ghetto, the so-called Judengasse (Jewish Alley). There is a permanent exhibition documenting the history of the street, the people who lived here and their homes, over a period of more than 300 years. The adjacent Börnegalerie presents small temporary exhibitions. Together, the Museum Judengasse, the Neuer Börneplatz Memorial and the Old Jewish Cemetery (1272–1828) form a unique historical ensemble. The memorial recalls more than 11,000 Frankfurt Jews who were murdered in the Shoah.

The documentation section of the Jewish Museum collects and archives materials pertaining to German-Jewish history for use in the preparation of exhibitions. Apart from a number of minor donations and estates, it also includes the Bernhard Brilling Collection (with the main focus on Silesia and North Rhine-Westphalia). The documentation section also has a picture archive with photographs of people, ritual utensils and community facilities throughout the German-speaking area.

The Ludwig Meidner Archive contains the artistic estate of this leading German expressionist. The archive also collects works by Jewish artists in exile and under persecution in the period 1933–45.

The museum library, which is available for use by visitors, currently houses more than 20,000 volumes on Jewish life and the history of the Jews in Germany and Central Europe, as well as films on topics related to the individual exhibition sections.

Some aspects are archived in data banks, including basic concepts, terminology and facts pertaining to Jewish life and history (Jewish Museum, second floor), as well as information on the history of the Juden-

gasse and the fate of the Jews deported from Frankfurt (Museum Judengasse).

The bookshop-café of the Jewish Museum (Buch-Café im Jüdischen Museum) is a popular meeting place, serving a selection of refreshments and vegetarian snacks, with an adjacent bookshop which is well stocked with relevant publications on the history and culture of the Jews (the bookshop also accepts orders).

At the time of first going to print, the Jewish Museum was about to enter its tenth year. Even today, the relationship between Jewish and non-Jewish Germans cannot be said to have achieved 'normality.' Yet the everyday work of this municipal institute, endowed with the task of collating, researching and maintaining the Jewish cultural and historical heritage, can point the way towards a better mutual understanding.

A Brief History of the Rothschild Palais

The Jewish Museum Frankfurt is housed in the historic building formerly known as Rothschild Palais (No.15) and the adjacent building (No. 14) on Untermainkai. No.15 is an outstanding example of the residence of an upper middle class Jewish family in the nineteenth century.

Both houses were built in neo-classical style in 1820/1821 by the municipal architect Johann Friedrich Christian Hess, who trained in Paris. The clarity of his formal syntax, based on the tenets of classical antiquity, underlines the quest for rational and functionally planned architecture, reflecting the spirit of the Enlightenment.

In 1823, privy councillor Simon Moritz von Bethmann, member of a leading Frankfurt family of bankers and councillors, purchased the house at No. 14. No. 15 was built for the banker Joseph Isaak Speyer, who came from a large and respected family that had resided in the Judengasse since the seventeenth century.

In 1846, Baron Mayer Carl von Rothschild purchased the house at No. 15 from banker Speyer's widow. In the course of the following years, he had it altered by Friedrich Rumpf, and extended westwards by five windows. Planned as a representative summer residence with park-like grounds, the addition of a second gable finally gave the building its present appearance. Moreover, Friedrich Rumpf created a new interior with reception rooms in the historicist style that came to be known as le goût Rothschild. The stairway with mirrors and coloured marble incrustations in Renaissance style (see below) leads down to the reception rooms, of which three salons have survived in their original form. They are the Louis XIV style wood-

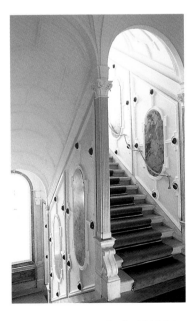

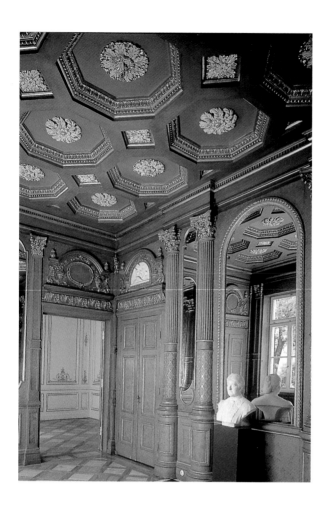

panelled 'smoking salon' (above) with fluted columns, mirrors and gilded coffering on a blue ground, which has housed a small Rothschild exhibition since 2001. The adjacent music salon in Louis XV style is decorated entirely in gold and white, with the arrows from the family coat of arms featuring in the gilded boiseries. The little salon in Louis XVI style has plain, pale green wall panels in the emergent neo-classical style of the day, while the ornately gilded stucco ceiling still bears all the hallmarks of rococo (see photo on p. 9). These three rooms are the only surviving examples in Frankfurt of the lifestyle of the Rothschild family, who consistently used aristocratic forms and cultural traditions to

project their image. During the lifetime of Baron Mayer Carl, part of his legendary collection of gold was presented in these rooms, which were turned into a museum after his death in 1886.

In 1895, the house at No. 15 was earmarked for use as a public library – the Baron Carl von Rothschild'sche öffentliche Bibliothek – founded in 1887 by Mayer Carl's daughter Hannah Louise von Rothschild (1850–92) and designated a foundation in 1893, following her death. In 1906, Baroness Salomon von Rothschild, Lady Rothschild and Baroness James von Rothschild purchased the house at No. 14 in order to extend the library. In 1928, with the foundation's capital devalued by rampant inflation,

the Frankfurt city authorities took over the Rothschild Library and house for use as part of the municipal library. Following a number of name changes, the last reference to the founding family being deleted in 1935, the city eventually merged the Rothschild Library with other Frankfurt libraries in 1945 to form the municipal and university library – Stadt und Universitätsbibliothek – with its headquarters in the virtually unscathed buildings at 14 and 15 Untermainkai. It was to be the main building of the municipal and university library throughout the immediate postwar years, until new premises were built near the university. Later it was used as an annexe of the Historisches Museum.

In 1980, the city council voted to establish a Jewish Museum in Frankfurt once again. The two buildings were refurbished (1984–1988) by the architect Ante Josip von Kostelac. While No. 15 was retained almost intact, including the surviving historical interior decor, No. 14 had to be gutted and given a completely new interior. The entrance to No. 15 was moved from the west side to the street front of No. 14 on Untermainkai. An interesting stylistic solution has been achieved by placing the large model of the Judengasse in the clear space of the two-storey foyer.

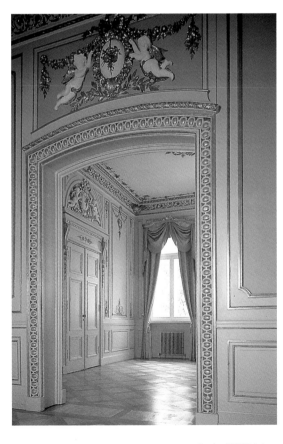

Jews in Frankfurt
1100–1800

Towards the Ghetto

The beginnings of Jewish life in Germany can be traced back to the fourth century of the Christian era. In the course of the Middle Ages and the early modern period, there was a marked deterioration in the legal and social situation of the Jews. Their expulsion from most of the imperial cities in southern Germany in the late fifteenth and early sixteenth centuries, and the establishment of the Judengasse in Frankurt as a closed area mark an important turn of events, illustrated by the architecture of the exhibition: from the late Middle Ages until their emancipation in the nineteenth century, Jews in Germany had to live behind barriers, both judicially and physically.

בני העיר שהלכו
לעיר אחר ופסקו עליהם צדקה נתנו וכשהן
באין מביאין אותה עמהן ומפרנסין בה עני
עירם 'במה דבר אמו בשאין שם חבר עיד כגון
בוורנקבורט וכיוצאבו 'אבל יש שם חבר עיד
שהלכו לעיר שיש בה יהודים תינתן לחבר
עיר ' חבר עיר 'חמדת עיר ' ויחיד שהלך לעיר
אחרת ופסקו עליו צדק תינתן לעניים של
אותה העיר '

First documentation of Jews in Frankfurt
From Rabbi Eliezer ben Nathan of Mainz' *Even ha Ezer* (Stone of Help), *c.* 1150
12th-century manuscript
Herzog August Bibliothek Wolfenbüttel

In his work *Even ha Ezer*, Rabbi Eliezer ben Nathan of Mainz reports a dispute between Jews about the religious obligation to give charity. He ruled that anyone providing a prospect of alms for the poor had to give the alms at the place where he had promised them. If, however, there was no administrative structure at that place, as was the case in Frankfurt, the donor could use his donation for the poor of his home town. This ruling shows that although Jews were in permanent residence in Frankfurt around 1150, there were so few of them that the community had no need of an administrative structure. In comparison with Eliezer's home town of Mainz and other towns on the Rhine, such as Cologne, Worms and Speyer, where Jews are documented in the early Middle Ages, the Frankfurt community would appear to have been relatively recent. In fact, it is likely that the establishment of a Jewish community in Frankfurt was closely linked to the beginnings of the Frankfurt trade fair, which is first mentioned in Rabbi Eliezer's work.

pp. 10–11: View of the exhibition area 'Towards the Ghetto'

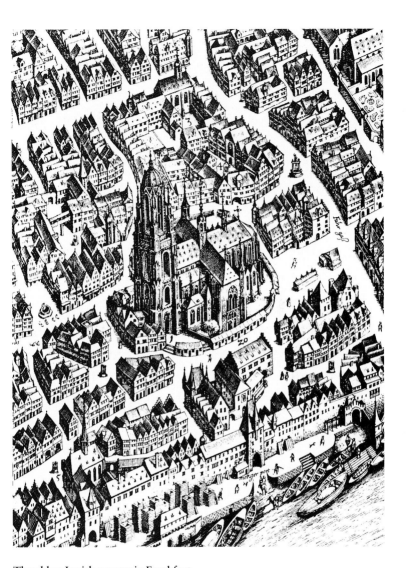

The oldest Jewish quarter in Frankfurt
From the city plan by Matthäus Merian, 1628
Historisches Museum Frankfurt am Main

In the first three centuries of their residence in Frankfurt, the Jews lived in the important area between the main church of St Bartholomew, the River Main and the lane called Fahrgasse leading down to the Alte Brücke which bridges the river. Far from being a closed Ghetto, this was a district where Christian and Jewish citizens lived side by side. The focus of Jewish life was the synagogue, part of which can still be seen – recognizable by the coat of arms with the Frankfurt eagle – behind the tower known as the Metzgerturm (in the middle foreground).

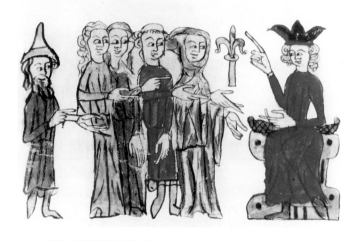

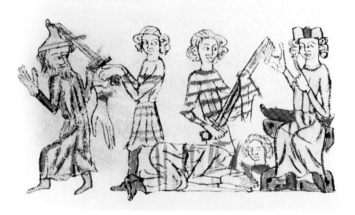

Jews under the protection of the king
From the Heidelberg illuminated manuscript of the *Sachsenspiegel, c.* 1330
Universitätsbibliothek Heidelberg

Since the massacres of the Rhenish Jews during the crusades, Jews had been accorded the special protection of the king, as had clerics and women. A Christian who killed a Jew faced execution on the grounds of breach of the royal peace. The distance between the Jew – recognizable here by the pointed hat – and the group of Christians in the upper picture indicates that Jews already occupied a separate position on the margins of Christian society, a situation that was to be further exacerbated in the course of the Middle Ages. The Jews were heavily taxed in ex-change for the king's protection. In reality, however, they could expect protection only when royal rule was strong. This is evident in the case of Frankfurt, where almost the entire Jewish community was killed in a pogrom in 1241. Although the citizens of Frankfurt were under his direct rule, Emperor Frederick II, already at loggerheads with the Pope, did not dare to call them to account for their crimes.

Jews burned alive during the southern German pogroms of 1298

Woodcut in Hartmann Schedel's *Chronicle of the World* of 1493. From Georg Liebe, *Das Judentum in der deutschen Vergangenheit*, Leipzig 1903, p. 21

The crusades fuelled the persecution of Jews in Germany, with attacks becoming more frequent and more violent. At the end of the thirteenth century, a wave of persecution swept through Southern Germany and Austria. Yet the Jews who had resettled in Frankfurt after the massacre of 1241 were not affected, nor were they victims of the second wave of pogroms that was unleashed thirty years later. In the plague year of 1349, however, when Jews were persecuted throughout Europe, the Jews of Frankfurt were killed or burned alive in their homes.

Before 1349, the members of the

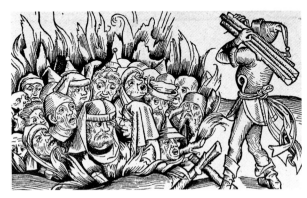

The Judengasse Ghetto in Frankfurt

From the city plan by Conrad Faber von Kreuznach, 1552
Historisches Museum Frankfurt am Main

Jewish community had lived under the direct rule of the king, just like their Christian neighbours, and had been almost their equals. When in 1360 a new Jewish community was established, the city became more or less independent of royal rule and was governed by a council of the leading families. Their legislation and the pressure of an increasingly anti-Jewish populace pushed the Jews increasingly towards the margins of urban society.

This development culminated in the Jews having to leave their traditional

district. They were resettled in a newly built, closed lane in the eastern part of town that had developed with the expansion of the city in 1333.

The city plan on p. 15 shows the old city walls of the late twelfth century, beside which the Judengasse was built, the tree-lined former city moat, the palisades on the ramparts and the two rows of houses that form the Juden-gasse. The Judengasse had three gates – north, west and south.

In the course of the Middle Ages, German Jews were gradually ousted from the fields of trade, crafts and agriculture. The only occupation left open to them was moneylending, since the church forbade Christians to lend money at interest. In order to pay their protectors high taxes, the Jewish moneylenders were allowed to charge high rates of interest. Thus, the wrath of the debtors was aimed at the Jews, rather than against the ruling classes.

From Moneylending to Trading

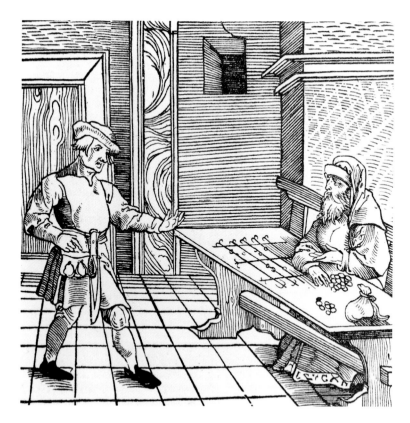

A peasant seeking credit from a Jewish moneylender, seated at a counting table
Woodcut in Cicero's *De Officiis* of 1531
From Georg Liebe, *Das Judentum in der deutscher Vergangenheit*, Leipzig 1903, p. 13

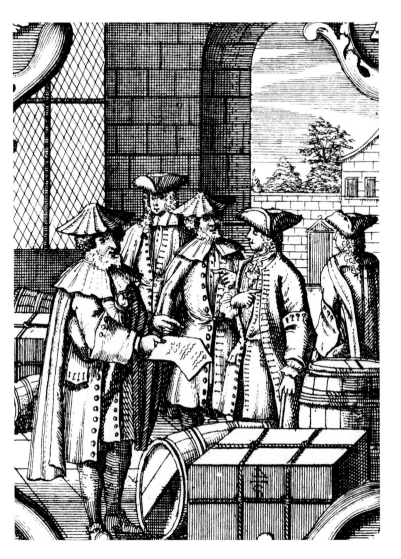

Jewish traders conversing with Christian clients
Copperplate engraving from Johannes Jodocus Beck's *Tractatus de juribus Judaeorum*, Nuremberg 1731, frontispiece
JMF 726

In spite of the church ban on usury, a Christian banking system did emerge in the early modern period which pushed the Jews out of the business of moneylending as well. This forced them to look once more to trade. The Frankfurt Jews profited above all from the city's two trade fairs, during which almost all restrictions were lifted. In the seventeenth and eighteenth centuries, some Jews became indispensable assistants to the princely courts around Frankfurt.

Life in the Frankfurt Ghetto

For more than three hundred years, the Jews of Frankfurt were isolated from the rest of society, living in the Judengasse from its inception in 1462 until its dissolution in 1796 under the influence of the French Revolution. During this time, the Frankfurt Jews made efforts to reduce the discrimination and restrictions of Frankfurt's regulations governing Jews, the Judenordnung. Yet the Christian community's deep-seated feelings of animosity and contempt towards the Jews, coupled with their business rivalry, meant that they were more inclined to maintain the status quo and, if anything, even tended to tighten existing restrictions. The city council sought to smooth the conflict without jeopardizing its own already barely tenable position. With the aid of the imperial court in Vienna, where the ideas of the Enlightenment were gaining ground, the Jews of Frankfurt managed to gain at least a modicum of freedom in the field of commerce.

View of the exhibition area showing 'Life in the Frankfurt Ghetto'
Mannequins dressed according to the engraving on p. 21

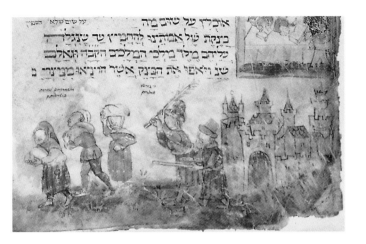

Jews being driven from a town in Germany, *c.* 1470
From a Haggadah manuscript, formerly in the Sassoon collection,
Jerusalem

At the same time as the Jews of Frankfurt were forced to move to the ghetto in the Judengasse, Jews were being driven out of most other Southern German cities. The displaced either settled in rural areas or moved to Poland. Frankfurt was one of the few cities that did not expel its Jews. The influx of Jews to Frankfurt from around 1550 onwards led to a considerable increase in the population of the Judengasse, making it the largest Jewish community in Germany.

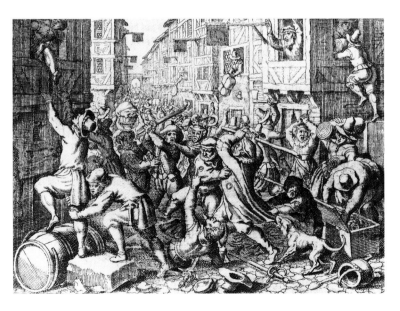

The looting of the Frankfurt Ghetto on 22 August 1614
Copperplate engraving from Johann L. Gottfried's *Historische Chronica* of 1657
JMF 86-52

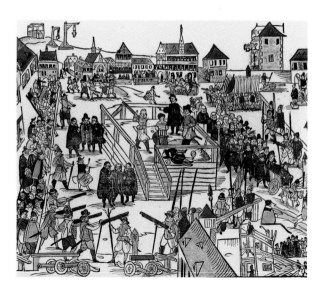

The execution of Vinzenz Fettmilch and his comrades, and the return of the Frankfurt Jews (right) on 28 February 1616
Woodcut in a contemporary pamphlet of Johann Ludwig Schimmel
Historisches Museum Frankfurt am Main

The city council, whose arrogance and incompetence had made it highly unpopular, was soon unable to contain the wrath of the Christian community at the increase in the Jewish population and the involvement of the Jews in Frankfurt's trading and business. At the height of a conflict with the guilds, who demanded greater participation in municipal government, the Judengasse was attacked and looted and the Jews driven out of Frankfurt. Ringleader Vinzenz Fettmilch and his associates were outlawed by the emperor and executed after the failed uprising in 1616. The Jews were allowed to return to Frankfurt.

After crushing the uprising, imperial commissioners drew up a new Judenordnung which remained in force until 1808. It included almost all the restrictions that had previously applied and limited the number of Jews residing in Frankfurt to the 500 families already living there.

Des
Heiligen Römischen Reichs Freyen Stadt
Franckfurt am Mayn
Stättigkeit
und
Ordnung
Der
Daselbstigen Juden,
Wie solche im Jahr 1616. errichtet,
Und
Von Kayser Matthias,
Allerglorwürdigsten Andenckens/
confirmiret worden.

The 'Judenordnung' regulating Jewish life in Frankfurt, 1616
Institut für Stadtgeschichte Frankfurt am Main

The Great Fire of 1711 destroyed the entire Judengasse
Contemporary copperplate engraving
Historisches Museum Frankfurt am Main

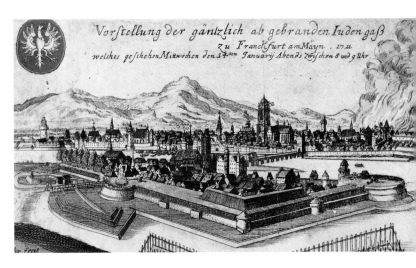

'Frankfurt Jew and Jewess'
Copperplate engraving by Christoph Weigel in Abraham a Santa Clara's Neu-Eröffnete Welt-Galleria of 1703
Historisches Museum Frankfurt am Main

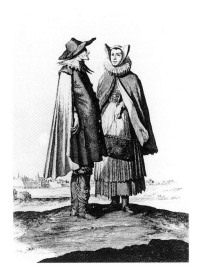

Since 1452, the Jews of Frankfurt had been obliged to wear a yellow ring on their chests. From the early eighteenth century, this rule was no longer enforced, and in 1728 it was officially repealed in Frankfurt. The woman and the man in this picture (left) are wearing the typical dress of the Frankfurt Jews around 1700. The woman has a bonnet with two peaks, a black cloak and a large ruff. The man has a black hat, a short black mantle and lace collar.

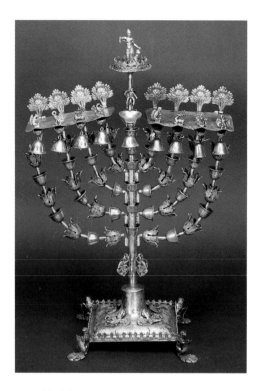

Hanukkah lamp
Frankfurt am Main, *c.* 1680, crafted by Johann Valentin Schüler (1650–1720)
Silver gilt, 51 cm high, 31 cm wide, 19.5 cm deep
JMF 87–79, bequest of Franziska Speyer (1844–1909)

This lavishly ornamented eight-branched candelabrum, which is lit during Hanukkah, the festival of lights (see p. 54f.), is based on the description of the original candlestick of the Jerusalem Temple as described in the Bible (Exodus 25: 31–38). Its base is a rectangular plate borne by four shield-bearing lions, bounded by a small gallery and ornamented with putti. Four branches, decorated with blossoms and bell-shaped components, extend on either side of the shaft. The eight holders for oil are crowned with olive trees, and there are bells on the spouts and animal figures on the lids: a squirrel, a stag, an eagle and a pelican on either side. The removable small oil jar on the central shaft is crowned by a male figure with helmet and weapons,

probably Judah Maccabee. The central shaft itself bears the figure of Judith with the head of Holofernes. The four animal figures are very probably references to four houses in the Judengasse and may even refer to the marriage of Moses Michael Speyer and Scheinle Bing-Kann in 1681. The bridegroom came from the house known as Goldener Hirsch (Golden Stag) and his mother from the house known as Goldener Adler (Golden Eagle). The bride came from the Eichhörnchen (Squirrel) branch of the family Goldene Kanne (Golden Jar) and her mother from the house of Pelikan (Pelican). Thus, the links between these four families are illustrated in the decoration of this candelabrum, which may have been a wedding present.

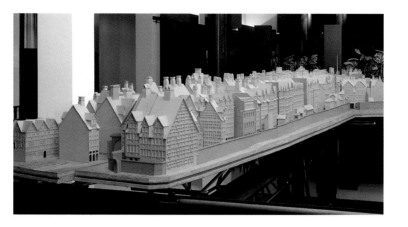

Self-administration

This part of the exhibition shows how life was organized in the Judengasse in Frankfurt, and presents the community's constitution and facilities. The focal point is a model of the Judengasse (see above) on a scale of 1:50, as it was after the great fire of 1711. During this time, three thousand people lived in cramped and unhealthy conditions in a Ghetto originally intended to house just one hundred.

The Jews of Frankfurt were more or less self-governing. The elders re-presented the members of the community before the city council and were responsible for the payment of taxes to the council. The elders and their assistants were in charge of the community's finances, judicial matters within the community, law and order in the Judengasse and supervision of the community facilities. As such, their judicial powers within the community were considerable. Although the head of the community, the treasurer and their assistants were elected, in fact administration was in the hands of the wealthiest families.

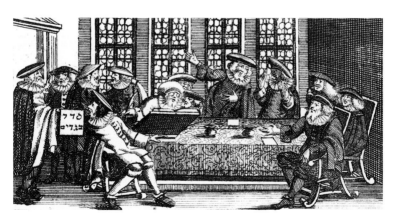

The Elders of Frankfurt's Jewish community decide on regulations governing dress and luxury
Copperplate engraving in Johann Jacob Schudt's *Jüdische Merckwürdigkeiten*. Frankfurt 1717, part 4/3, p. 74
JMF 3616

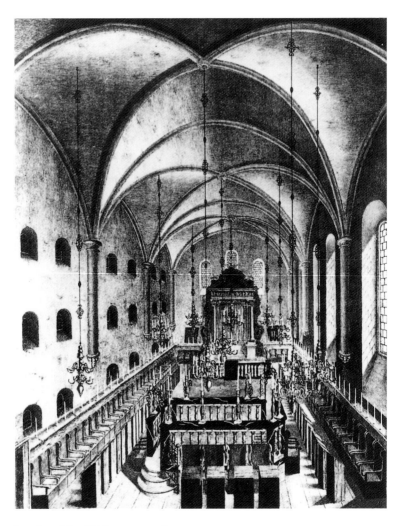

Interior of the Old Synagogue of 1711
Lithograph by Ernst Pichler, *c.* 1840
Historisches Museum Frankfurt am Main

The synagogue is the spiritual centre of the community. In the eighteenth century, there were four synagogues in Frankfurt: the Alte Synagoge, or Old Synagogue, in the north-east section of the Judengasse, with an annexe for women; the adjacent Neue Synagoge, or New Synagogue; the synagogue in the so-called Klause or Talmud school in the south-east section; and the synagogue in the almshouse by the cemetery. Religious services in these synagogues were organized by the members of the community themselves, and the cantors.

Kiddush cup of the Frankfurt community
Southern Germany, *c.* 1600
Gold, 15 cm high, 9 cm wide
Original in Israel Museum Jerusalem
Reproduction
JMF 85-2

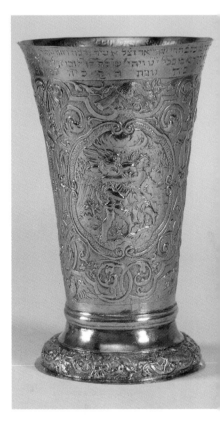

The original of this cup, used for the recital of blessings over wine to mark the commencement of Shabbat and other festivals, was presented to the Frankfurt synagogue from the estate of Michael J Speyer in 1764. In November 1938, the director of the Historisches Museum saved the cup and other items in the Museum of Jewish Antiquities from being confiscated by the Gestapo. In 1951 it was passed on to the Israel Museum in Jerusalem by the Jewish Cultural Reconstruction. The inscription reads "Cup of David by which to thank God in song and joy. Donated to the honour of God by the famous elder and benefactor, the honourable Mr Michel, son of Mr Jossel, Speyer, blessed be the memory of the just, who gave with a pure heart. He donated a significant sum for a number of good things, and among those that he gave the synagogue was this cup with which to recite kiddush on each holy day. His sacrifice will be 'a memorial before the Lord eternally' [Exodus 28:29]. His heirs have fulfilled his wish and testament today, Wednesday, 2 Tevet 5525 [25 December 1764, i.e. 30 days after his death]."

The illustration shows the struggle of Jacob with the Angel (Genesis 32:25). On the other side of the cup is the Sacrifice of Isaac (Genesis 22:9-12) and Jacob's Ladder (Genesis 28:12).

Rabbi Naftali Kohen (1649–1719) with two of his students
Painting by Johann Andreas Benjamin Nothnagel, 1772
Historisches Museum Frankfurt am Main

The rabbi is the spiritual head of the Jewish community, traditionally ruling on issues of conflict within the community, the highest authority in questions of ritual and ceremony, and teacher of the Talmud. He supervised weddings and divorces and was expected to educate the community in matters of religion through his sermons. The large Jewish community in Frankfurt had several rabbis under the leadership of a senior rabbi. The rabbi in charge of the Talmud school, or Klause, was known as the 'Klaus-rabbi.' In the seventeenth century in particular, Frankfurt was an important centre of religious study and the home of many leading rabbis.

Animosity towards Jews

This anti-Jewish fresco was created inside the northern tower of the Alte Brücke, the old bridge across the river Main, towards the end of the fifteenth century, and was repeatedly renovated until well into the eighteenth century. It denigrates the Jews, dressed in the Frankfurt Jewish garb of the early eighteenth century, in the vilest manner. They are depicted eating faeces and drinking the milk of pigs (which are unclean according to Jewish tradition). The pig's uncleanliness is emphasized by having it eat faeces as well. In the picture, the Jews are being egged on by the devil himself, who is portrayed with the same facial traits as the Jews, suggesting that the Jews are related to the devil. The goat, which the Jewish woman is holding by the horn, is also a satanic creature. The Frankfurt fresco combines widespread derogatory prejudices with the Blood Libel of ritual murder.

Johann Jacob Schudt (1664–1722), a Protestant theologian, orientalist and school rector in Frankfurt, wanted above all to see the Jews converted to Christianity. Although he harboured all manner of anti-Jewish prejudices, he remained sceptical with regard to the Blood Libel accusing the Jews of ritual murder and the desecration of the Eucharistic Host. For all its shortcomings, Schudt's *Merckwürdigkeiten* is a text that provides a number of invaluable insights into contemporary Jewish life in Frankfurt.

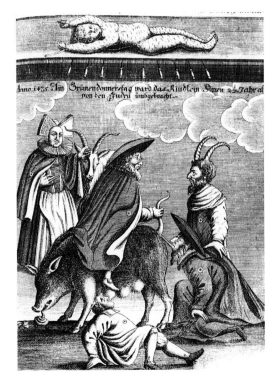

The Frankfurt "Judensau"
Copperplate engraving in Johann Jacob Schudt's
Jüdische Merckwürdigkeiten,
Frankfurt 1714, part 2, facing p. 257
JMF 3616

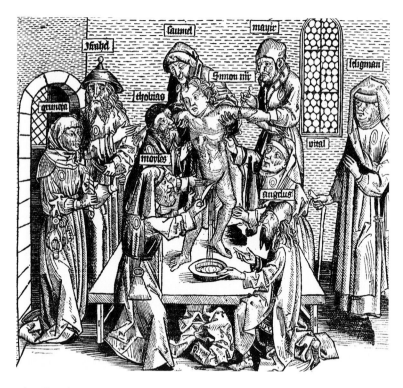

The alleged ritual murder of Simon of Trent, 1475
Woodcut by Michael Wolgemut in Hartmann Schedel's *Chronicle of the World* of 1493 JMF 86-51

Since the early Christian era, the Jews had been accused of refusing, through malice and blindness, to recognize Jesus as the Messiah foretold by the prophets, and of causing his death on the cross. From the Middle Ages onwards, Christian preachers accused them of new and even more heinous crimes. The Jews, they claimed, murdered Christians, especially children, to use their blood for their ritual ceremonies. Although the emperor and the pope refuted the Blood Libel and forbade its dissemination, it continued to be widely believed.

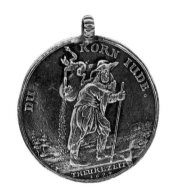

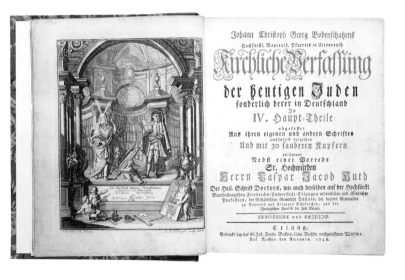

Title page of Johann Christoph Georg Bodenschatz' work on the rites and customs of the German Jews
Frankfurt, Leipzig and Erlangen 1748–49
23 cm high, 19 cm wide
JMF 8929

The Protestant reformer Martin Luther initially hoped to win over the Jews to his teachings. When these hopes failed to come to fruition, he called for harsh measures against the Jews, with a severity rivalling the old church. It was not until much later that his followers found more appropriate forms of approaching the Jewish community. Johann Christoph Georg Bodenschatz (1717–97), a Protestant theologian, orientalist and minister in Uttenreuth near Erlangen, sought to compile a truthful outline of the religious and private customs of the German Jews in the mid-eighteenth century, illustrated by a number of copperplate engravings.

'Du Kornjude'
Anti-Jewish medallion, 1694
diameter 3.6 cm
JMF 89-129

From the sixteenth century onwards, apart from the traditional anti-Jewish accusations of a religious nature, Jewish business success became the focus of charges of Jewish fraudulence and trickery against Christians. This medallion claims that Jewish grain merchants are responsible for price rises. In the course of the centuries, these accusations imprinted a deeply negative view of Jews in the minds of the general population, providing fertile soil for the anti-Semitic movement of the nineteenth century and, later, for National Socialism.

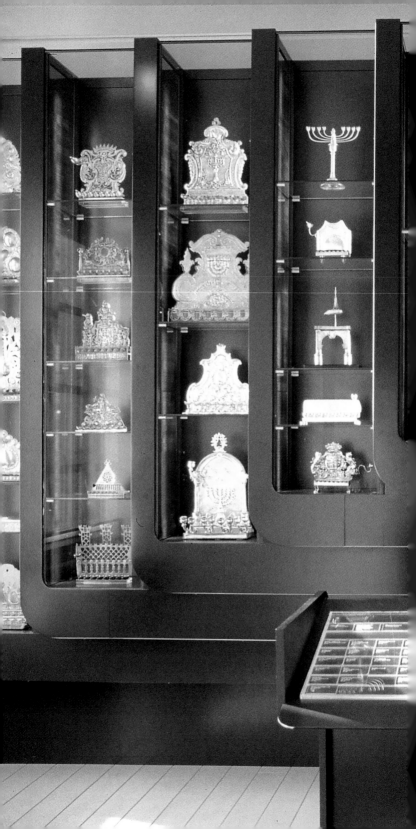

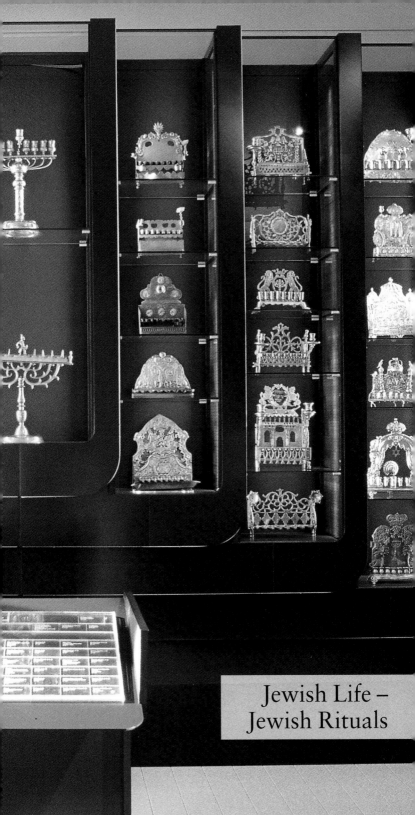

Jewish Life –
Jewish Rituals

The Spiritual Background of Judaism

Judaism is a religion based on ritual in which religious practice is not restricted to the synagogue but is part and parcel of the community's festivals throughout the year and everyday life within the Jewish home. Almost all the biblical festivals and historical memorial days have their own specific ritual objects for celebration. Without the ritual objects a festival cannot take place. For this reason, liturgical instruments play an important role in traditional Jewish life. The following section presents the principal ceremonies performed at the synagogue and at home, illustrating them by way of example of the ritual objects used.

The presentation of the synagogue indicates the multi-functional nature of this facility within the Jewish community and the significance of the Torah as the spiritual basis of Judaism. An entire room is dedicated to the Shabbat, the most important holy day in the home, as indicated by the ritual objects used to mark its entrance and its end. Also, the various stations of life, from circumcision and bar mitzvah to marriage and burial, are associated with special ceremonies and specific objects that make the individual's involvement in the Jewish community all the more tangible. The biblical festivals of Passover, Shavuot and Sukkot are as much an expression of collective memory as the historical memorial festivals, and all serve to nurture Jewish tradition and maintain the identity of the community. Nevertheless, Jewish communities in the diaspora have always been integrated into their non-Jewish environment, and the enormous diversity of the objects used to celebrate the Shabbat and Hanukkah gives an insight into the regional varieties of the rites that have developed in European Jewish communities in the course of the centuries.

The Museum's collection was built up mainly in the 1980s, through purchases and donations. It includes a number of outstanding items from the old Frankfurt Jewish Community as well as items from the Netherlands, Central and Eastern Europe and North Africa.

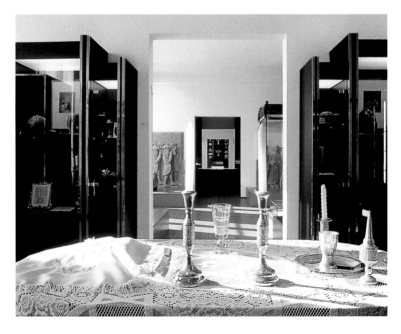

Frankfurt Passover Haggadah
Frankfurt am Main, 1731, illuminated manuscript on parchment
25.7 cm high, 18.2 cm wide
JMF 88-31, donated by Ignatz Bubis
Shown here: detail of folio 11a depicting the Exodus from Egypt (Exodus 12:37)

The Haggadah, or Passover story, is a collection of biblical texts, religious stories, songs and rites pertaining to Passover. The text of the Haggadah is recited during the ritual Seder meal that is eaten at home on the first two nights of Passover, in memory of the last meal eaten by the Israelites before the Exodus from Egypt.

The earliest illustrated Haggadah manuscripts appeared in Western Europe in the thirteenth century, but the main body of the text was actually set forth by Babylonian scholars in the ninth century.

The Haggadah manuscript shown here was handwritten and illustrated in 1731 by Jakob Michael May for his parents and is based on a printed Haggadah from Amsterdam. The scribe was a member of a respected Jewish family of court agents from Innsbruck that had held important positions in the courts and Jewish communities of several Southern German cities.

Here, the Exodus from Egypt is depicted in the garb of the present day: the Exodus appears as a solemn procession of people wearing the finery of the eighteenth century, much as they would when taking a Shabbat stroll before the gates of the Juden-gasse in Frankfurt. Recalling history through the eyes of the present is an important aspect of Judaism and the Haggadah is an excellent example of this form of remembrance.

pp. 30–31: **Hanukkah lamp display**

p. 32: **The Museum's 'Feasts and Festivals' section**

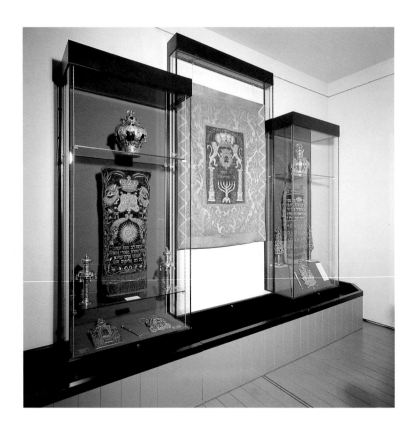

The Synagogue

In the diaspora, the synagogue (from the Greek, a 'place of gathering') became the spiritual centre of every Jewish community. This is the place for religious services and where the Torah is read publicly. The synagogue was also a place of learning and of passing on spiritual and intellectual traditions, as well as the place where the rabbinical court would issue his rulings. Architecturally, the style of the synagogue varied according to the social and political situation of the respective community. It might be no more than a small room, or no less than a large and impressive building. Its most important features are the Ark containing the Torah scrolls, situated in an elevated position in the east wall of the synagogue, and the large lectern at which several members of the community can recite the text of the Torah together. From the Middle Ages onwards, special sections were provided for women, usually in the form of galleries.

The most important items in any synagogue are the Torah scrolls, for they are its only sacred possessions. Accordingly, their significance is reflected in the sumptuous fabrics of its decorative mantle and the ritual silver implements with which they are decorated. The silver ornaments of the Torah scroll may take the form of a shield and crown, or the ends of the two scroll handles may have silver finials. There is usually a pointer in the form of a hand, which is used to indicate each word without touching the parchment. A curtain hangs in front of the Ark, often bearing the motif of a gateway with pillars, recalling the entrance to the Holy of Holies in the Temple of Solomon which will be rebuilt in the Messianic era.

The Torah

The Torah scroll contains the text of the Pentateuch, the Five Books of Moses, which tell the biblical story from the Creation to the Promised Land of Canaan and which include the laws and commandments revealed to Moses in the wilderness. It is the basis for the life of every Jewish community.

A portion is recited each Shabbat, with up to as many as seven members of the community being called upon to read. Prayers are led by the Hazzan, or cantor, who masters the art of reciting the prayers.

Because of the enormous significance of the Torah, there are strict rules governing the production of the Torah scroll. It must be written by hand on the parchment of a kosher animal, in a total of 284 columns. The parchment sections are sewn together in a long scroll and rolled onto two staves. The scribe must be specially trained, and may only use a certain type of quill and specially produced ink. The text may have no errors, and may not be altered or embellished by any ornament that might hinder its legibility or alter the original text. Since the second century, the text has been divided into 54 sections so that a new text can be read each Shabbat. The completion of the Torah readings is celebrated by the festival Simhat Torah ('Rejoicing of the Torah') in autumn, immediately after Sukkot (the harvest festival or Feast of Tabernacles).

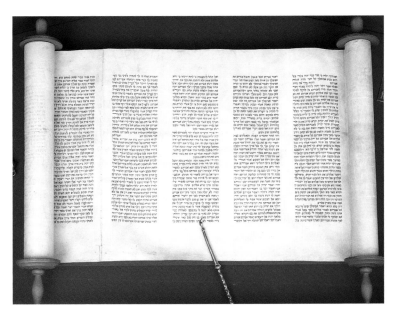

Raising the Torah scrolls in a Paris synagogue
Eduard Brandon
Paris 1869
Oil on canvas
60 cm high, 40 cm wide, JMF 89-90

Eduard Brandon (1831–97) was a painter in the circle of the Barbizon School who had direct contact with the impressionists, most notably Degas. He became known for his portrayals of traditional Jewish life, modelled mainly on the Sephardic community in Paris. This painting probably shows the interior of the Sephardic synagogue in the rue de la Victoire. The painting was shown at the 1869 Salon in Paris to critical acclaim.

The Hazzan in the white garment known as a kitel has removed the Torah scroll from the Ark, which is indicated by the open curtain behind him, and is about to bring it to the lectern. As he does so, he recites a blessing from the prayer book in his left hand. In front of him stand the members of the community, approaching the scroll with reverence. The women's gallery can be dimly discerned above. Behind the Hazzan, other members of the community have removed a second scroll from the Ark, indicating that this is a special holy day. The flow of light and the golden-brown hues lend the scene a ceremonial solemnity that is centred on the recital of the Torah. The ceremony of taking out the Torah scroll and removing its mantle, lifting it at the end of the reading, wrapping it again and placing it back in the Ark

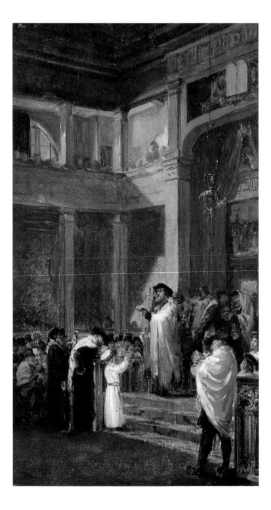

is central to the formal liturgy of the service in any synagogue, emphasizing the significance of the Torah to the Jewish community.

Torah finials (rimonim)
Hallmark: Amsterdam 1708
Silver gilt, 47 cm high, 14 cm diameter
On loan from the Jewish Community of Frankfurt
am Main

The pagoda-like hexagonal towers consist of four rows of arcades, with balustrades and bells, and a crown. The finals are mounted on the ends of the two staves of a Torah scroll. The staves are described as trees of life, for they hold the Torah scroll whose text is the basis of Jewish life. This metaphor is also applied to the finials, which are known as rimonim, the Hebrew word for pomegranates, these being traditionally the fruit of the Tree of Life. Whereas the Torah finials in Eastern European and Turkish communities often take the form of apples or spheres, Western European Torah scrolls tend to be decorated with towers. This is presumably derived from the form of a royal sceptre, underlining the dignity of the Torah. The arcaded finials are typical of the Amsterdam communities and the form itself is modelled on contemporary Amsterdam church spires, such as that of the Nieuwe Kerk which stood in the immediate vicinity of the Jewish quarter until 1942. This reflection n urban Christian architecture indicates the degree of acculturation of Amsterdam's Jewish community.

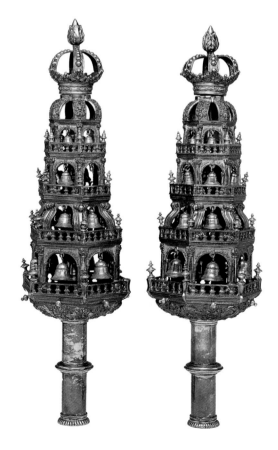

Torah shield
Frankfurt am Main, 1700, possibly the workshop of Johann Abraham Boller
Silver gilt with a gilded copper back
32.5 cm high, 27 cm wide; JMF 87-106

This Torah shield is a cut-out silver foliage mounted on a gilt copper panel, upon which the Tablets of the Law are set. Above them two lions bear a crowned cartouche, with the Hebrew inscription 'Sacred to the Lord.' Between the Tablets of the Law there is a little box containing metal plaques with the names of the holy days on which the Torah (that is to say, the Torah scroll this shield once adorned) is to be read. The shield still has its original bells and chain. This Frankfurt Torah shield may well be modelled on contemporary Torah shields from Nuremberg, the contours resemble a baroque architectural facade. The blossom and leaf design is typical of the workshop of Johann Abraham Boller (1697–1732), who, together with the workshop of the brothers Johann Valentin and Johann Michael Schüler, produced a number of ritual objects for the community in the Judengasse. Torah shields have been documented as ritual objects since the fifteenth century and were particularly commonplace in the German (Ashkenazi) communities. If the community was poor, the Torah shield and pointer were often the only ornamentation of the Torah scroll.

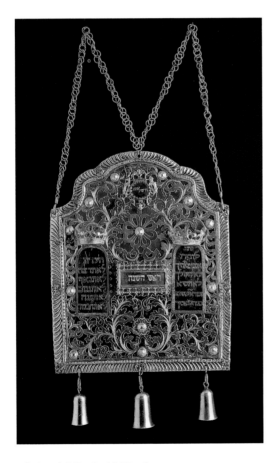

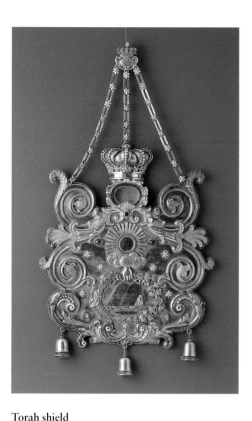

Torah shield
Master's mark: E. Schürmann & Co.
Frankfurt am Main, *c.* 1875, silver, partly gilded, enamel and glaze
30 cm high, 26.5 cm wide
JMF 95-3
Donated by former Frankfurt mayor Hans-Jürgen Moog

The shield with the sweeping contour is a typically historicist blend of neo-baroque and neo-classicist forms. In the central nimbus is the Shema (Hear, O Israel), which is an affirmation of monotheism. The name of God appears in the centre. The hand emerging from the clouds holds a wreath of oak and palm leaves with the Tablets of the Law. In the now empty medallion below the crown, there was probably originally an inscription referring to the patron or donor. The Torah shield still has its original bells and an elaborate star-studded chain.

This unusual iconography reflects a quest for new visual metaphors in the age of assimilation. The affirmation of faith does not appear on ritual objects before the emancipation. This Torah shield emphasizes the analogy between the Jewish and Christian religions. The Tablets of the Law are a traditional motif in Frankfurt Torah shields. In this particular example, however, they are portrayed in combination with oak leaves and palm fronds, indicating the symbiosis between German Christians and German Jews.

Eduard Schürmann ran a silverware business in Frankfurt from 1867 onwards which supplied a number of ritual objects to the Jewish community of the city. A respected ritual silversmith, he was also commissioned to create the chain of office still worn today by the city mayor.

Jewish Life

Torah binder
Aufhausen, Swabia
Linen, embroidered with silk
16 cm high, 341 cm wide
JMF 88-100
Donated by the HaBonim community,
New York City

In the German-speaking Ashkenazi communities from Alsace to Bohemia it was customary to sew a long band known as a 'wimple' out of the swaddling cloths worn by a boy at his circumcision. The wimple was embroidered with the Hebrew name and date of birth of the child and a blessing for his future. This band was then used in the community to wrap the Torah scrolls and was at the same time an indication of membership of the community.

This particular wimple was made for Jakew Zwi of the rural community of Aufhausen in 1823. The blessing 'May he grow up to the Torah, the huppah and good deeds' is illustrated by a Torah scroll and a wedding canopy. The Torah scroll is a reference to the bar mitzvah ceremony in which the boy is called upon to read the Torah, while the wedding canopy, or 'huppah,' indicates the founding of a new family,and the reference to 'good works' calls upon him to contribute to community life through charitable works.

The letters have been painstakingly drawn in an old-fashioned script and embroidered over in rope-stitch using silk yarns of different colours. The lettering was drawn by a scribe trained in the art of ritual manuscript-writing, and the embroidery was done by the women of the family.

Cushion cover for circumcision chair
Middle Rhine late-17th century
Linen with embroidery, 67 cm high,
71.5 cm wide
JMF 96-2

In seventeenth- and eighteenth-century Germany, there was a special double chair in the synagogue for the ceremony of circumcision. One seat was reserved for the godfather who held the child during the circumcision, and the other was reserved for the Prophet Elijah, whose symbolic presence was expressed by a sumptuously embroidered cushion. The child was placed on the cushion shortly before the actual circumcision.

The cushion is made of fine, hand-woven linen, with flat-stitch embroidery in different coloured silk yarns and metal threads. The embroidered motto quotes sections of the circumcision liturgy and the biblical Covenant with Abraham involving the circumcision of his male descendants.

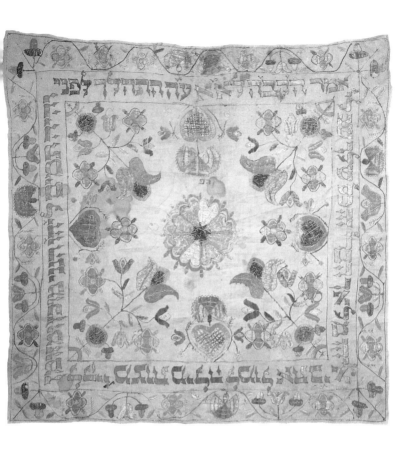

Though they have now faded, the colours must originally have been a bright rendering of carnations, tulips and imaginary flowers. They were inspired by the Ottoman style then en vogue and typical for the late Baroque.

Circumcision utensils

Eastern Europe, 19th century
Jug 12.9 cm high, Austro-Hungarian
hallmark;
Dish 3 cm high, 9 cm diameter,
Russian hallmark;
Knife 13.8 cm long, steel blade and
horn handle
JMF 85-69
Donated by Ignatz Bubis

These three items, though not original-
ly a set, represent the basic instruments
used by the mohel, the specially trained
ritual circumcisor, who is also requir-
ed to keep a register of those circum-
cised.

The ritual calls for a very sharp,
small knife with no notches or nicks,
with which the foreskin is removed.
The foreskin is then placed on a special
dish and covered with sand. The jug
probably contained oil or some other
ointment with which to treat the
wound and stem the bleeding.

Circumcision is one of the most im-
portant of all Jewish rites, for it defini-
tively determines a man's membership
of the community. Just as the Lord
commanded Abraham to circumcise
Isaac in recognition of the Covenant,
the Bible calls for every male Israelite
to bear this sign.

Circumcision is performed on the
eighth day after birth in the presence
of at least ten males of the community.
The ritual is accompanied by a reli-
gious ceremony with blessings and
prayers. In traditional Ashkenazi com-
munities, the circumcision takes place
in the synagogue, and women do not
participate in the actual ceremony.

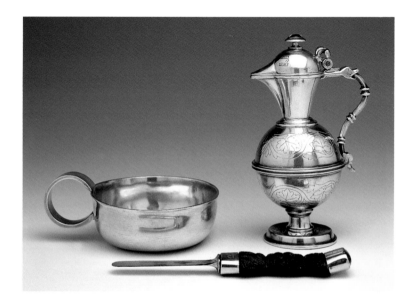

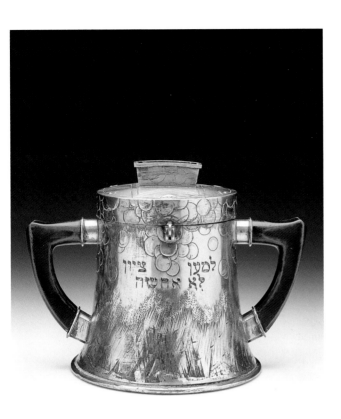

Tzedakah box
Master's mark: Leo Horovitz
Frankfurt am Main, *c.* 1910
Silver, engraved
18.5 cm high, 28 cm wide
On loan from Ignatz Bubis

The most important obligation of the
various fraternities of any Jewish com-
munity consisted in collecting money
for charity (tzedakah). For this reason,
there were many such collecting boxes
in every community. Sometimes the
precious metal of the boxes themselves
were a pledge for sums to be donated.
This box has an unusual iconography
indicating the purpose for which the
money collected was to be used. The
conically tapering cylindrical body
bears a bas-relief portrayal of a field of
grain moving in the wind, with rain-
clouds gathering over it. The coin-like

clouds symbolise the shower of gold
by which Eretz Yisrael, the Land of
Israel, is to be transformed into fertile
soil. Thus, this collecting box mirrors
the Zionist hopes for a new homeland
in the Land of Israel.

Goldsmith Leo Horovitz (1886
Gnesen–1961 London) was the son of
Marcus Horovitz, an orthodox rabbi
of the Börneplatz Synagogue in Frank-
furt who initially rejected Zionism, but
later gave it his enthusiastic support.
This commitment may well have
prompted his son Leo Horovitz to
create a new a topical iconography for
this traditional item.

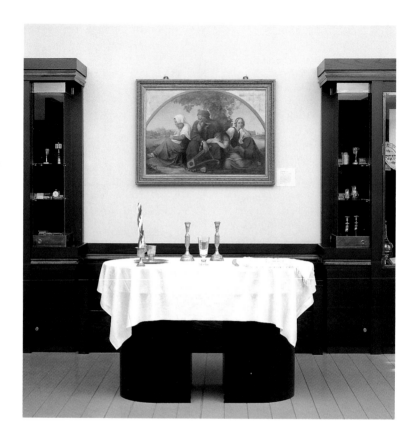

The Shabbat and Festivals

The family's observance of the Shabbat at home is as central to Judaism as reciting the Torah in the synagogue every Shabbat. The very fact that observing Shabbat is included in the Ten Commandments underlines the special significance of that day. God himself having rested from the work of Creation on the seventh day is the very reason behind the commandment of rest, while it is also an eternal remembrance for the Israelites freed from bondage in Egypt. The celebration of Shabbat begins on Friday evening, when Kiddush is recited and the blessings over wine and bread are said. It ends with the ceremony of Havdalah on Saturday night, marking the separation of the sacred and profane, of the end of the holy day and the start of a new week. The strict prohibition on working calls for careful preparation on the eve of the Shabbat, and in observant households the week's work is organized around the holy day. Since cooking is work and therefore prohibited on the Shabbat, the housewife has to prepare all three meals in advance, taking into account the dietary laws or Kashrut, such as the strict separation of meat and dairy products, which in observant households requires double sets of specially marked dishes.

Furthermore, it is the solemn duty of the housewife to light the candles at the entrance of the Shabbat. In Ashkenazi homes until the nineteenth century, star-shaped hanging lamps of brass were used, which were lowered every Friday evening.

Besamim tower (spice box)
Lemberg (Lviv), *c.* 1806
Silver filigree, enamel, Austrian
hallmark
51 cm high, 8.9 cm diameter
JMF 89-105
Donated by Josef Buchmann

This box for spices (besamim) takes
the form of a hexagonal tower with
a curved spire set on a high, facetted
base and stem ending in a knob. The
tower is made of silver filigree and the
base is reinforced with gilded silver
plates. In the six arcades of the tower
there are small figures painted with
enamel. Five of them are wearing the
broad-rimmed black hat and long coat
typical of German and Eastern
European Jews. The sixth figure is a
dark-skinned Indian with a crown of
feathers, grass skirt and spear. Each
of the five men is making a gesture or
holding an attribute relating in some
way to the havdalah ceremony. The
sequence begins to the right of the
Indian with the two figures holding the
wine cup and prayer book, followed
by the man who sees the light of the
havdalah candle reflected on his finger-
nails and the man with the actual
havdalah candle. The man with the
tiny spice box is the last in the se-
quence, next to the Indian. In the eigh-
teenth-century imagination, the Indian
was a Moor, which in turn is easily
associated with 'mor,' the biblical
Hebrew word for myrrh. Myrrh could
well have been kept in such a spice
box. The iconography is legible only
with a knowledge of Jewish rites and
the absence of a master's hallmark
could indicate that it was the work of
a Jewish silversmith. Jewish craftsmen
were allowed to practice in Lviv as
long as they worked only for Jewish
clients. As they were not allowed to
become members of the guild, they
were not permitted to have their own
master's hallmark.

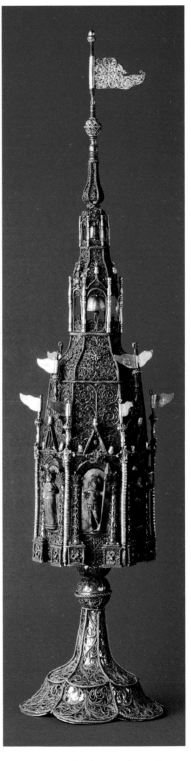

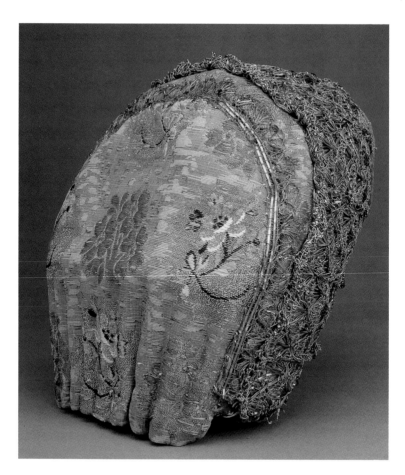

Woman's bonnet (kupke)
Poland, 19th century
Brocade, trimmed with gold lace
15 cm high, 13 cm wide
JMF 86-19b

Judaeo-Christian tradition holds that a married woman should cover her hair. For observant Jews, this led to the ceremony of cutting the hair of the bride and ceremoniously adorning her with a wig after the wedding. This wig, or 'sheitel,' as it is known, was worn by married women in the Jewish communities of Central and Eastern Europe in particular, whereas a lace bonnet tied under the chin was a more common head covering in Western Europe. In Poland, the wig took the form of a cover of pleated black silk or black velvet. Less frequently, it consi-

sted of the hair cut during the wedding ceremony and subsequently rearranged. On the Shabbat and holy days a small cap of sumptuous fabric was worn over the wig, framing the forehead. Lace was a typical feature of such caps, and particularly ornate caps even had 'Spanish lace' woven with gold thread.

Man's feast day hat
Frankfurt am Main, 18th century
Silk velvet with gold embroidery
17.5 cm high, 42.5 cm wide
JMF 87-58

Men are also required to cover their heads in the synagogue and during prayers, and many pious Jews even wear a small skullcap, known as a kipah, at all times. Until their emancipation, the Ashkenazi Jews customarily wore a beret out of doors and a kipah at home. On feast days such as Passover, ornately embroidered caps were worn, derived from the bonnets worn by Christian men at home in the eighteenth century as a substitute for a wig. Instead of the simple silk or cotton fabric and plain embroidery of the Christian caps however, the caps made for Jewish clients often featured velvet and gold or silver threads, in keeping with the importance of the event for which they were worn.

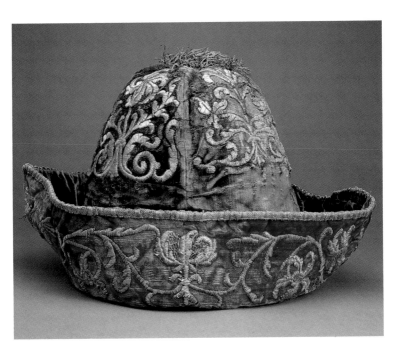

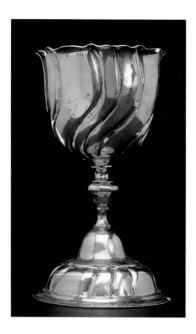

Kiddush cup
Master's mark: Röttger Herfurth
Frankfurt am Main, *c.* 1760
Silver gilt
13.3 cm high, 6 cm diameter
JMF 87-121

Kiddush is the ceremony of reciting
blessings over a cup of wine at the
beginning and end of almost every
Jewish festival. Moreover, kiddush is
recited at ceremonies of circumcision
and marriage. The wine blessing sym-
bolizes the sacred nature of the cere-
mony or festival and is one of the most
important rituals in Judaism. Every
Jewish household has at least one kid-
dush cup, whose important function
is indicated by its form or material, or
by an inscription designating its use.

Although the cup shown above bears
only the Hebrew mark of the owner
on the reverse of the base, its precious
material and ornate form indicate that
it is a ritual object. In the mid-eight-
eenth century it was the typical form
of kiddush cup used in the Judengasse
in Frankfurt.

Besamim box in the form of a cockerel
Poland, 19th century
Silver repoussé, 15.3 cm high, 10.2 cm
wide
JMF 85-41
Donated by Ignatz Bubis

The Shabbat ends on Saturday evening
with a ceremony symbolically marking
the separation (havdalah) of the sacred
time of Shabbat and the profane time
of the new week. After the wine bles-
sing and the lighting and extinguishing
of a candle of twisted wicks, a box of
spices (besamim) is passed around.
The pleasant scent is intended to recall
the peace and calm of the Shabbat.
In the course of the centuries, these
boxes developed a wide variety of
forms, differing from region to region
and according to the wealth of the
owner. In the traditionally-minded
communities of Western Europe, the
tower was a frequently used form
from the Middle Ages onwards, while
some orthodox communities in
Eastern Europe developed new forms
influenced by the folk art of the region.
The cockerel, which features in many
Eastern European Jewish tales, is
just one example. Another popular
spice box form is the fish, which is
widely regarded as a Jewish symbol
of happiness.

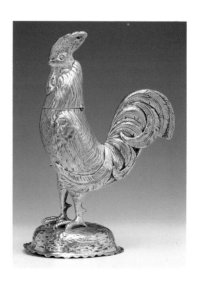

New Year card
Printed in Frankfurt am Main for the American market, 20th century
Paper, embossed
28 cm high, 17 cm wide
JMF 92-4

This New Year card opens up to reveal two pictorial levels, one behind the other, creating a stage-like sense of space. In the background, against a white and gold colonnade with forget-me-nots, four men in a solemn procession are carrying the Torah scrolls from the Ark, accompanied by two boys waving flags. In the foreground level, a boy is being blessed by a white-bearded rabbi in a white robe, or kitel. The English inscription reads Happy New Year. These two scenes show the first and last holy days of the autumn festival period that marks the beginning of the Jewish year. The kitel worn by the rabbi in the lower scene indicates the New Year celebration of Rosh ha-Shanah (New Year) and, ten days later, the fast day of Yom Kippur (Day of Atonement), when white shrouds are traditionally worn. The boys waving flags indicate the ceremony of Simhat Torah (Rejoicing of the Torah), which is celebrated thirteen days after Yom Kippur.

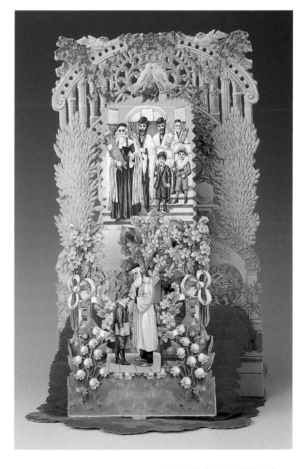

Passover plate
Master's mark: Johann Heinrich Hersing
Hallmark: Bielefeld, after 1739
Pewter, etched and engraved, 42 cm diameter
JMF 87-332
From the collection of Bruno Italiener

This plate was intended for the symbolic dishes served at the ritual seder meal during Passover in memory of the last meal eaten by the Israelites before their Exodus from Egypt. The date and name of the owner are engraved in the centre and on the rim. The plate belonged to the community official Jeremia, son of Jakob of P.b. (possibly Paderborn) and his wife, Serche, daughter of Samuel Moses Segal. The inscription was completed on 4 Shevat 1744. The owners' inscriptions are accompanied by portrayals of the Fall of Man, the Sacrifice of Isaac, the Four Sons, and David and Solomon who feature in the Passover story of the Haggadah.

The engraving is in the style of folk art, with naively rendered figures based on contemporary illuminated manuscripts which, in turn, imitate printed Hebrew books.

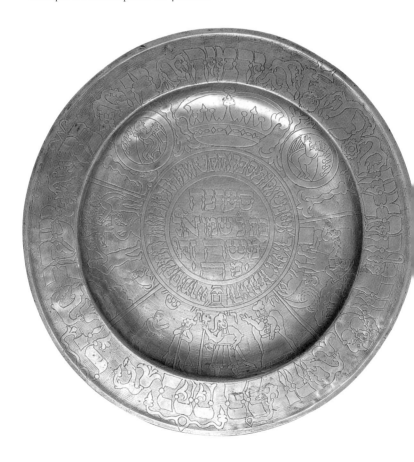

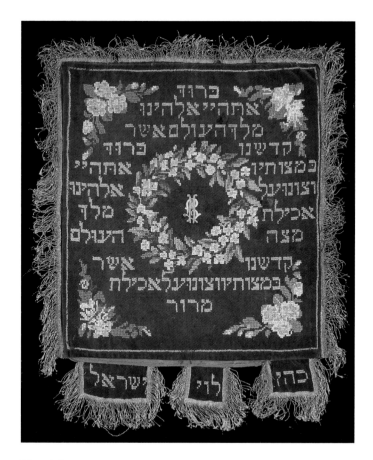

Matzah bag
Germany, late 19th century
Cotton velvet with embroidery and gold fringes
42 cm high, 40 cm wide
JMF 85-9

The almost square bag of violet-brown velvet contains three compartments for the unleavened bread (matzah) that is eaten at the ritual seder meal during Passover. The compartments bear the Hebrew designations Cohen, Levi and Israel, in reference to the recipients of the unleavened bread in biblical times: the priests of the Temple (pl. Cohanim, sing. Cohen), their assistants (Levites), and all other members of the People of Israel. On the top, embroidered in cross-stitch, are Hebrew blessings for eating the matzah and bitter herbs. Within an embroidered wreath of forget-me-nots and roses is the owner's monogram in ornamental Latin script. Together with the seder plate, the wine cups and the haggadah, Matzah bags such as this, either round or square, are an important component of the traditional Passover celebration. Some wealthy families had a silver device of four superimposed trays, with matzah placed on the three lower trays and the symbolic dishes in various small vessels on the uppermost tray.

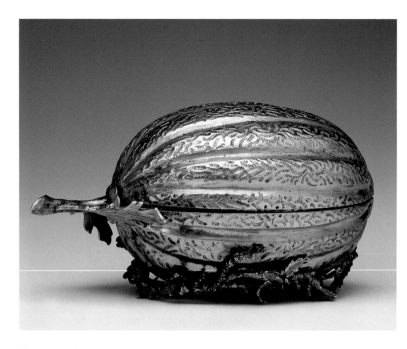

Etrog container
Master's mark: Georg Wilhelm Schedel
Hallmark: Frankfurt am Main, after 1722
Silver gilt, 9.5 cm high, 19 cm wide
JMF 87-110

This box in the form of a large citrus
fruit on a silver wreath of oak leaves
was intended to hold the etrog, which
is one of the bouquet of 'four species'
bound together for the autumn harvest
festival of Sukkot in memory of the
forty years the People of Israel spent in
the wilderness. Because it was so diffi-
cult for many diaspora communities
north of the Alps to obtain the etrog,
and since it could only be used if it was
unblemished, the citrus fruit was kept
in a special container.

The bouquet of four species consists
of willow, myrtle, palm and etrog. It
is paraded around the synagogue on
each day of the festival and shaken
in the four heavenly directions. Folk
tradition associates the four species
with four different types of character:
the magnificent and fragrant etrog
symbolizing good-looking people with
charisma; the elegant but dry palm
branch symbolizing the beautiful but

uncharismatic; the pleasant myrtle
representing the charismatic but plain;
and the simple willow standing for
those who have neither good looks nor
charisma.

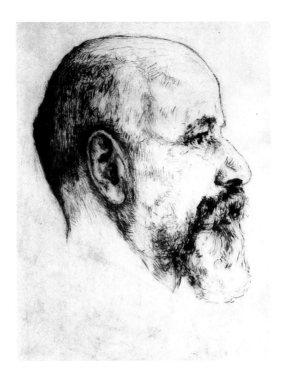

Portrait of Siegmund Nauheim (1874–1935)
Etching by Jakob Nussbaum
Frankfurt am Main, 1929
24 cm high, 19 cm wide
JMF 88-53

The Collection of Hannukah Lamps in the Jewish Museum Frankfurt

The Museum holds a large and important collection of the eight-branched lamps used to celebrate the Hanukkah festival of light. The collection gives an insight into the enormous diversity of forms that developed in the course of the centuries throughout Europe and the Near East. Some of the items are from the collection of the Museum of Jewish Antiquities in Frankfurt, which, in 1936, received as a bequest the collection of Siegmund Nauheim, head clerk of the Rothschild Bank in Frankfurt am Main. His collection included books, manuscripts and other Jewish items, among them more than a hundred Hanukkah lamps. Siegmund

Nauheim was not only a collector, but also a scholar, who had painstakingly sought out these items according to epoch, style and country of origin at a time when these were not considered collectors' items. In 1938, the Museum of Jewish Antiquities was looted and most of the collection destroyed. The silver lamps were melted down. Lamps made of non-precious metals were considered to be of no value and were deposited in the Historisches Museum. In 1987, these lamps were restored and integrated into the collection of the Jewish Museum. This collection has since been extended by donations from Meta Gorski and Ignatz Bubis, and by occasional purchases.

Hannukah lamp
Germany, 18th century
Brass and copper, repoussé and stamped
30 cm high, 28 cm wide, 10 cm deep
JMF 87-202
Siegmund Nauheim Collection

The festival of lights known as Hanukkah recalls the rededication of the Temple and its golden Menorah following the victory of the Maccabees over the Seleucid rulers of Palestine in the second century BCE. During the eight-day festival, the eight lights of the lamp are lit in succession – one light more on each successive day – using a special kindling light.

This lamp has a rectangular drip tray with the eight oil fonts set above it. The back wall is the recycled shield of a grenadier's helmet from the troops of the United East India Company, rein-forced with a copper plate. A number of Hanukkah lamps of this type have survived, suggesting that the military iconography of the grenadier's shield featuring sabres, canons and grenades may have been regarded as a particu-larly suitable means of representing the historical background to the Hanukkah festival.

This lamp lacks the kindling light that was originally inserted in the backplate at the top right.

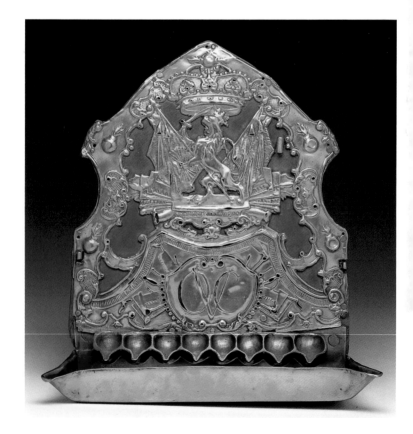

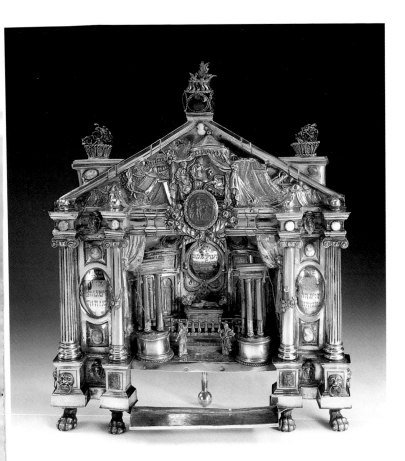

Hannukah lamp
Master's mark: Johann Fridolin Schulthes
Koblenz, *c.* 1790
Silver repoussé, set with stones
35 cm high, 32.5 cm wide, 6.5 cm deep
JMF 94-3

The tray (the eight lights are missing) fronts a stage-like structure whose aedicula type architecture, complete with columns, frames a semi-circular altar area with the Ark of the Covenant, before which the silver figurines representing Moses and Aaron stand like actors. A number of individual features of this detailed and finely crafted architecture refer to the temples of classical antiquity which had so recently been rediscovered. The gable relief depicts the story of Judith and Holofernes, an event generally held to have occurred around the time of the rededication of the Temple of Solomon. The cameo above the architrave depicts the Sacrifice of Isaac.

The city of Koblenz, where this lamp was made around 1790, had a small but important and long-established Jewish community which included a few wealthy individuals, some of them court agents to the Archbishop of Trier. This unusual Hannukah lamp may well have been commissioned by such a client.

Scroll of Esther
Italy, 18th century
Parchment with sepia ink, illustrated
27.8 cm high, 208 cm wide
JMF 88-37
Shown here: columns 5 to 7

The biblical Book of Esther, telling the story of Queen Ester, who saved her uncle Mordecai and all the Jews of Persia from annihilation, is read on Purim, the festival celebrating their escape from danger. The text is handwritten in twelve columns on a parchment scroll. Between the columns are the figures of the main characters in the story, from the Persian king Ahasuerus and his first wife, Vashti, to Esther, Mordecai and the villain Haman. The oriental garb, medallions and animal motifs on a dark ground recall the copperplate engravings made by the Jewish artist Shalom Italia for such Esther scrolls in the early seventeenth century. These, like the Haggadah, were printed in Amsterdam and were a major export commodity for many European communities. In the eighteenth century, when the printed scrolls of the Book of Esther with the illustrations by Shalom Italia were no longer available, they became the model for illuminated manuscripts written in sepia ink, such as this one.

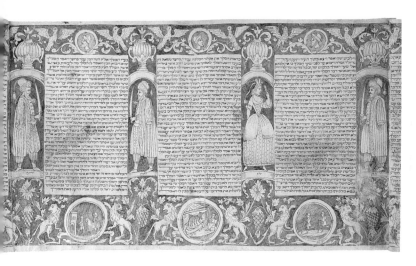

People of the Book – People of Books

This room is dedicated to some three thousand years of Jewish literature. Two wall panels bearing the name of the room tell of the structure of the Hebrew Bible, the Mishnah and the Talmud, as well as other Jewish writings.

The Bible comprises the five books of the Torah (teachings or law), the eight books of the neviim (prophets) and the eleven books of the ketuvim (writings). Towards the end of the second century of the Christian era, the teachings and laws of the oral Torah were written down in the Mishnah (memorized teachings). Tradition has it that the oral Torah was revealed along with the five books of the written Torah and then passed on orally from generation to generation. The rabbis, learned and literate, studied and discussed the Mishnah, and their commentaries, continuing in the oral tradition, led to the Talmud (study or teachings). The Talmud, sometimes likened to an ocean, is encyclopaedic in its treatment of the teachings of the rabbinic academies and their canon. Apart from discussing the religious laws, it also addresses legends, anecdotes, history, natural science and even astronomy.

The focus of this section (see photo) is, unsurprisingly, a display of various editions of this most fundamental of works in the form of a rabbinic bible (containing not only the basic text, but also Aramaic translations and commentaries by great scholars), a Mishnah, also in German translation, and an edition of the Babylonian Talmud published in Frankfurt between 1720 and 1723 by Johann Kölner, a Christian printer who worked with Jewish publishers, typesetters and proofreaders because they themselves had no printing rights due to the influence of the guilds on the city council.

Work on this edition was begun in Amsterdam by Samuel Marches and Rafael Palasios in 1714–17, and was

Top: **Mikra'ot gedolot** (rabbinic bible), Wilna, Romm, 1899;
Centre: **Mishnah**, Berlin, I. Lewent, 1832, and Mishnah in the German translation by Johann Jacob Rabe, Onolzbach, Jacob Christoph Posch, 1761;
Bottom: **Babylonian Talmud**, Frankfurt am Main, Johann Kölner, 1720–23
JMF 2829, Bernhard Brilling Collection, 4593 and 3778

continued in Frankfurt for financial reasons (from the third tractatus of the third order). The proofreader was Samuel Schotten, head of the Frankfurt yeshivah (Talmudic college). It was funded by the Viennese court factor Samson Wertheimer. Later, it came to be used as the basis for other printed editions of the Talmud. Almost all the

sections in the book bear the imperial eagle and censors' clearance on the title page, along with the colophon 'In Frankfurt am Main gedruckt bei Johann Kölner.' A copy of this Talmud specially printed on parchment was purchased by David ben Abraham Oppenheim (1664–1736) for 1,000 guilders.

A portrayal of the development of Jewish religious law (halakhah) from the revelation on Mount Sinai to the sixteenth-century codification adopts the metaphor of the 'Sea of the Talmud' in a huge luminous image of the 'Sea of the Halakhah.'

The wall panel dedicated to Books and Scholars presents some of Frankfurt's learned writers and their most important works through the centuries. The wall panel on Book Printing presents the actual physical production of Jewish books in Frankfurt and the surrounding area through the ages.

Large slides showing a wide variety of typographical styles with titling in two languages can be seen on a light desk.

The bookcases, which lend something of a library atmosphere, also contain some interesting examples of works translated into Hebrew from many languages. The book shown on this page is a Hebrew translation of Goethe's poetry, published in a bibliophile edition in Jerusalem in 1949.

Finally, no section on books would be complete today without the 'electronic lexicon.' Three screens are available for visitors to browse, with cross-references to people, places, festivals, religious services, writings and other sections of the museum. Not that it can compare with a visit to the library itself to read the actual books.

Poems by Goethe
Hebrew translation by Immanuel Olsvanger (1888–1961)
Jerusalem, Sifre Tarshish
(Dr Moshe Spitzer), 1949
21.5 cm high, 14.5 cm wide
JMF 3073

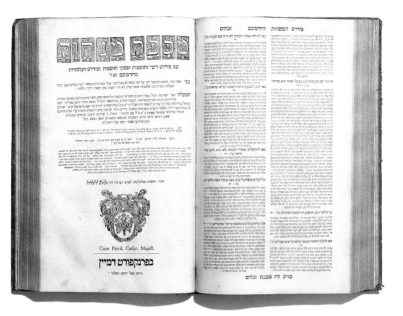

Babylonian Talmud

With the commentary by Rashi (Rabbi Solomon ben Isaac, 1040–1105), supplements (Tosafot), remarks on decisions (Piske tosafot) and the Mishnah commentary of Rambam (Moses Maimonides, 1135–1204). 18 volumes
Amsterdam, Samuel Marches and Rafael Palasios, 1714–17
Frankfurt am Main, Johann Kölner, 1720–23
32.5 cm high, 20.5 cm wide
JMF 3778

The book is lying open at the tractate on menahot (food offerings; see Leviticus 2 and 5 through 7, and Numbers 6 e.a.) which discusses the required intention of an offering, its suitability or unsuitability under certain circumstances, its preparation, and the occasions on which an offering should by made.

It is in volume 15 of the 18-volume work, which contains the tractates on *kodashim* ('holy things') from the fifth of the six Mishnah sections, dealing with sacrifices and their context.

1824 Israelitische Bürger

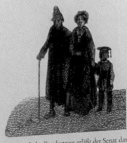

Auf Druck des Bundestages erläßt der Senat das »Geset
über die privatbürgerlichen Rechte der Israeliten«.
Die Juden werden »israelitische Bürger«, bleiben aber von
allen politischen Rechten ausgeschlossen.

Das Gesetz enthält auch im privatbürgerlichen Sinn nich
die völlige Gleichstellung: Für jüdische Kaufleute, Hand
werker und Fabrikanten bleiben mehrere Ausnahmebe
stimmungen bestehen.
Die Juden empfinden als besonders diskriminierend, da
die Eheschließungen weiterhin reglementiert werden
Jährlich werden 15 Ehen zugelassen, nur bei 2 Ehen dar
ein Partner von auswärts kommen.
Israelitischen Bürgern wird gestattet, überall in der Stad
Häuser und Gärten zu mieten und Läden zu eröffnen.

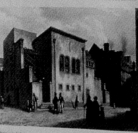

1825 Ringen um Anerkennung

1825 Jüdische Juristen setzen die Zulassung als Rechtsanwälte
 durch von Notariat bleiben sie ausgeschlossen.

1830 Das »Frankfurter Museum für Wissenschaft und Kunst«
 nimmt Juden als Mitglieder auf.

 Philipp Veit – getaufter Enkel von Moses Mendelssohn –
 wird Direktor des Städtischen Kunstinstituts.

1832 Gabriel Riesser gibt die Zeitschrift »Der Jude« heraus.

 Sie kämpft langfristig für die Gleichstellung der Juden.

1834 Nach widrkehrlicher Gesetzen der jüdischen Gemeinde
 werden Heiratsbeschränkungen aufgehoben, wenn beide
 Brautleute aus Frankfurt sind.

1836 Aufhebung aller Handelsbeschränkungen für Juden nach
 dem Anschluß Frankfurts an den deutschen Zollverein.

1837 Herausgabe der »Allgemeinen Zeitung des Judentums« in
 Leipzig, dem bedeutendsten jüdischen Presseorgan.

 Die Lesegesellschaft »Die Aufnahme von Juden ab.

1840 Zusammenschluß von Liberalen in politischen Diskus-
 sionsclubs. Teilnahme vieler Juden.

1842 Gründung des »Reformvereins«, einer radikal-liberalen
 jüdischen Vereinigung.

 Der Gesangverein »Liederkranz« und die Casino-Gesell-
 schaft lehnen die Aufnahme von Juden ab.

1845 Tagung einer Versammlung liberaler Rabbiner in Frank-
 furt mit dem Ziel, allgemeine gültige Bestimmungen über
 das Wesen des Judentums zu treffen.

 Das von M. Rothschild gegründete »Montagskränzchen«
 wird Zentrum der Liberalen.

1846 Die Eheschließung von Juden wird nicht behindert, wenn
 ein Vermögen von 5000 Gulden nachgewiesen wird.

Jews in Frankfurt
1800 – 1950

Enlightenment and Education

The conditions under which the Jews lived changed little up to the end of the eighteenth century. They remained subject to special laws, confined to the Judengasse and restricted to money-lending and small-scale commerce as a means of earning a living. A number of changes began to emerge with the Enlightenment, and although these initially applied only to individuals, they soon affected the Jews as a social group, with far-reaching repercussions for the cohesion of the community as a whole. In Frankfurt, however, the living conditions of the Jewish population did not improve to any noticeable degree until the period of French occupation.

Education and learning were central tenets of the Enlightenment and seen

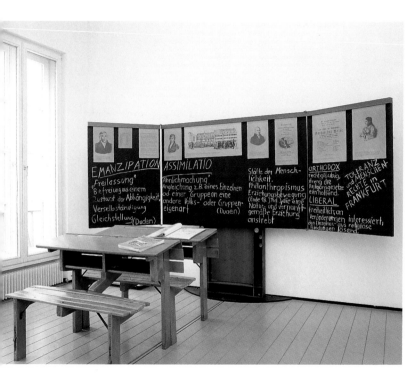

The Museum's 'Enlightenment and Education' section

as the prerequisite to changing the way the majority of the population and a minority group lived together and interacted. Its express aims were to dismantle prejudice and promote mutual interest and understanding. The Christian 'reform schools' and the liberal Jewish schools founded in the late eighteenth and early nineteenth centuries eptomize this fresh start.

pp. 60–61: The Museum's 'Integration and Assimilation' section (see p. 68)

Prayers for Rosh ha-Shana with German translation
Compiled and translated by W. Heidenheim. New and revised edition,
Rödelheim 1872, 18.3 cm high, 12.2 cm wide
JMF 11281

Moses Mendelssohn
Austria, 19th century, ivory relief in ebony frame with ivory applications,
20 cm high, 13.5 cm wide
JMF 88-21

Moses Mendelssohn (1729–86), was
the leading figure of the Jewish En-
lightenment. He was a philosopher,
enlightener and teacher of the Jews.
Born in Dessau in 1729, he went to
Berlin at the age of 14 'to learn.' Once
there, he set about studying German,
Latin, English, French, Mathematics
and Philosophy 'day and night.'
Mendelssohn earned a living as a
Talmud scribe. Later, he was tutor to
the family of a silk manufacturer,
eventually becoming their accountant
and, on the death of his employer, a
co-proprietor of the company.

Gotthold Ephraim Lessing and the
bookseller and publisher Friedrich
Nicolai encouraged Mendelssohn in
his philosophical enquiries, debating
with him and urging him to write and
publish. Together, they fought against
prejudice and ignorance, calling for
tolerance, human rights and the equal
rights of Jews.

Lessing immortalized Mendelssohn
in his play *Nathan the Wise*, which

infuriated part of the Christian com-
munity. In 1779, for instance, the
Frankfurt city council prohibited the
staging of the play on grounds that
it had 'the most scandalous content
with regard to religion.'

Mendelssohn, who had acquired
a knowledge of the German language
under the most arduous conditions,
called for Jews to be taught German
at school. He also insisted, however,
that they should be familiar with
Hebrew. His German translation of
the Pentateuch (the Five Books of
Moses) in Hebrew characters was
intended to teach German along with
the main tenets of the Jewish faith.

In what is now the district of
Rödelheim in Frankfurt, the scholar
Wolf (Benjamin) Heidenheim founded
a publishing house in which prayer
books were printed in German and
Hebrew. Although Hebrew remained
the language of the religious service,
value was placed on ensuring that the
texts were genuinely understood and

on conveying individual prayers in German as well. The Heidenheim editions were widely disseminated. To this day, reprints of his books are labelled and known worldwide as the Rödelheimer Edition.

Dr. phil. Jakob Weil
Painting by Gottlieb Herz
Frankfurt am Main, 1844
Oil on canvas
44 cm high, 37 cm wide
JMF 86-65
Gift of Madeleine Elsaß, London

Jakob Weil (1792 Bockenheim–1864 Frankfurt) was a teacher and publicist. From 1814 to 1819 he taught at the Philanthropin, later becoming director of a liberal-religious Jewish private school, the Weil'sches Knabeninstitut, which existed at least until 1844. He was an active member of the community board, who published theological works and penned treatises advocating equal rights for Jews. Gottlieb Herz at times taught drawing at the Philanthropin.

The notion that a mastery of the German language and a general edu-cation in the rudiments of arithmetic and writing were the most important stepping stones towards bridging the difference between the majority and the minority is reflected in the number of Jewish schools established for children of low-income families unable to afford a private tutor. Teachers were recruited among members of the community who had studied at university, and they took up the task with idealism and enthu-siasm. In 1804, following years of conflict between conservative rabbis and members of the community on the one hand, and reformers on the other hand, the school 'Das Philanthropin' was founded in Frankfurt as a school of the Israelite community offering Jewish and non-Jewish children an education from kindergarten through to university entrance level. The Philanthropin was closed in 1942.

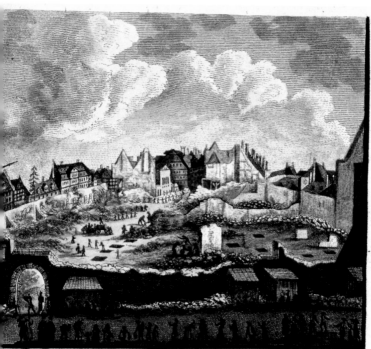

Brandstätte der Judengasse in Frankfurt a/m am 16 Jul. 1796

The Judengasse on fire, 14 July 1796
Contemporary drawing
Historisches Museum Frankfurt am Main

In the last third of the eighteenth century, the Jewish community and individual Jews wrote a number of letters to the Frankfurt city council and citizenry requesting an improvement of the living conditions in the Judengasse. They pointed out the poor hygiene and the difficulty of educating their children to become 'useful citizens'. The council dismissed their requests.

Military events brought unexpected change. In the night of 13 to 14 July 1796, Frankfurt was bombarded and conquered by French troops. The houses in the northern section of the Judengasse went up in flames. 140 houses were destroyed and 1,800 Jews made homeless.

The fire put an end to the forced confinement in the Judengasse. The subsequent public debate about rebuilding the houses and establishing a Jewish ghetto clearly indicate that although a few had changed their views of Jews in the course of the Enlightenment, there was no general consensus in favour of changing the socio-political situation.

Emancipation and Exclusion

Unlike the rest of Frankfurt's citizens, many Jews welcomed the government installed by Napoleon, expecting it to enforce equal rights for all in accordance with the regulations prevailing in France, and took steps to assert ensure this. In France, the National Assembly had passed a law in 1791 revoking all rules of exception and investing the Jews of France with the rights and duties of French citizens.

Instead of the anticipated introduction of equal rights, Karl Theodor von Dalberg, appointed governor of Frankfurt by Napoleon, passed a new ordinance with 151 sections, which meant that the Jews of Frankfurt were still subject to special regulations and had to pay 22,000 guilders a year for protection.

While all other groups in Frankfurt approved the new regulations, the Jews railed against their enforcement with hitherto unparalleled vehemence. In their 'battle by the pen' they criticized the rivalry of craftsmen and merchants, the church's fear that the foundations of the Christian state might be undermined, and the patrician classes' interest in maintaining a social homogeneity based on lineage and wealth.

At Napoleon's intervention, the situation of the Jews did eventually improve. In 1810, Napoleon established the Grand Duchy of Frankfurt and demanded the introduction of the French civil code, including the equality of all citizens. After long and difficult negotiations, a bill was passed at the end of 1811 recognizing the equality of Frankfurt's 'Schutzjuden' ('protected Jews') before the law.

French Occupation and Civil Rights
The Tree of Liberty based on a watercolour by Johann Wolfgang von Goethe (1792) symbolizes Jewish hopes for equality in the spirit of the French Revolution. The custom of erecting a Tree of Liberty, symbol of the French Revolution, was also adopted in Germany in 1792.

**Letter from Karl von Dalberg to Mayer Amschel Rothschild dated
11 December 1811** (the first of three pages)
21 cm high, 17 cm wide
JMF 87-138.10

Dalberg confirms the proposed method of payment with regard to the 440,000
guilders due for equal rights: 100,000 to be paid immediately, and 50,000 in
each of the next two years, followed by an annual payment of 10,000 guilders

In their negotiation for equal rights,
the members of the Jewish community
petitioned respected and wealthy indi-
viduals famous far beyond Frankfurt.
A letter from Dalberg to Rothschild
points out that the Jews had to pay
440,000 guilders for equal rights
before the law. This was twenty times
the amount they paid annually for
their protection. The community had
enormous difficulty raising such a
sum. The Rothschild bank and the
(non-Jewish) Bethmann bank helped.

In January 1812, the Frankfurt Jews were finally granted the equal rights for which they had fought so long and at such expense. But by 1814, with the end of the French occupation following the defeat of Napoleon, they were revoked. A chronological outline (see pages 60–61) shows the difficult path towards equality. Two sub-sections (Integration and Identity) present the effects of emancipation. Although Frankfurt received a new constitution in 1816, Article 1 clearly stated that 'All sovereign rights and self-administration of the city are based on the Christian citizenry as a whole.' The Jewish community protested and called for definitive equal rights. Yet all they achieved was a compromise: in 1824, Jews were granted the status of 'Israelite citizens,' and though some of the special regulations were revoked, others remained in force.

In 1848, the National Assembly that convened in the Paulskirche in Frankfurt as a result of the liberal revolutionary movement granted Jews full rights of citizenship and nationality. Yet the Assembly was short-lived and so, too, were the new-found rights of the Jewish citizens. Then in 1864, Jews were finally granted equal rights in Frankfurt, followed in 1869/71 by the rest of the German Reich. A few administrative restrictions nevertheless remained in place, barring Jews from becoming military officers or professors, for example.

Problems of Integration

The fact that the law of 1824 restricting the number of marriages had not been repealed was considered particularly discriminating. It meant that all those wishing to marry, whether they were doctors, lawyers or bankers, had to obtain a marriage permit from the Senate. If the intended spouse was not from Frankfurt, rights of citizenship had to be applied for. The applications often took years to process. In the case of Hermann Schiff, whose application was acknowledged in January 1842, the marriage could not take place until 1847.

The Jewish community refused to let the matter rest. Although there was some relaxation of the regulations prior to 1864, especially for wealthy Jews, the Senate refused to repeal them.

In spite of the restrictions, the number of Jews in Frankfurt continued to rise steadily, from 3,000 in 1800 to 4,500 in 1823, 5,000 in 1847 and 7,620 by 1864. In all, Jews accounted for about ten per cent of the population.

The Senate's reply to Frankfurt merchant Hermann Schiff's application for his fiancée to be granted citizen's rights. Dated 13 January 1842, the official letter calls for 'patience.'
33 cm high, 20.5 cm wide
JMF A 534

Medallions of the Lodge of the Rising Sun
45 cm diameter
JMF B 89–28.1
Formerly owned by Theodor Creizenach, who taught at the Philanthropin school in Frankfurt and later at the Höhere Bürgerschule

Though emancipation had begun, education and culture did not open the doors to the important and influential circles in Frankfurt, for most associations and societies upheld their statutes barring Jews from membership. The fact that the Freemasons' Lodges which were not traditional societies, but Enlightenment institutions, also refused to accept Jews was regarded as particularly harsh.

In protest, some Frankfurt Jews founded the Loge zur aufgehenden Morgenroethe (Lodge of the Rising Sun) in 1807 and in 1832 the Loge zum Frankfurter Adler (Lodge of the Frankfurt Eagle). Although these lodges were expressly open to Jews and non-Jews, few non-Jews actually joined. The lodges became important as meeting places and discussion forums, and most liberal Jews who had some standing in the community became

Sashes with the colours of the Suevia fraternity of Hanover and the Nassovia fraternity of Frankfurt, 1929, a 'Weinzipfel' tag with the colours of Nassovia, Frankfurt, and a cap of Thuringia, Breslau
Sashes *c.* 3 cm wide; Weinzipfel 1.5 cm wide, 18 cm long;
Cap 15 cm diameter; JMF B 87/13.25, .6, .5, .7

members.The student fraternities mentioned here were part of the 'Convent of German Students of Jewish Faith' that was founded in 1896 with the aim of 'combatting anti-Semitism among students and educating our members to become self-assured Jews.' The gradual

progress of legal emancipation and the ever-present anti-Semitism which became increasingly evident after 1870 led to the foundation of a number of Jewish associations with similar aims to that of the student associations. They included sports and youth associations and women's associations.

Advertising stamps
Frankfurt, *c.* 1900
6 cm x 4 cm and 4 cm x
5.5 cm
JMF B 96/6.2, B 86/862,
B 96/6.5

In the 1920s, the occupational outfitter
S. Morgenstern was one of the leading
textile retailers on the Zeil, Frankfurt's
main shopping street. Frank & Baer
Manufactur- und Modewaren, Betten-
und Wäschefabrik was founded in
1875 and also had a large outlet on the
Zeil. The wine merchant Feist, founded
in the late eighteenth century, enjoyed
an excellent reputation far beyond
Frankfurt.

Until 1836, Jews were subject to a
variety of economic restrictions. In par-
ticular, small-scale Christian merchants
and traders restricted Jewish competi-
tion, while the guilds made it difficult
for Jews to work in the field of crafts
and manufacturing. The only area in
which Jews could trade without restric-
tion was money changing and money
lending.

The last economic restrictions were
lifted when Frankfurt became a mem-
ber of the Zollverein, a customs union.
Frankfurt developed into a centre of
South-West German trade and built up
its traffic and transport infrastructure
accordingly. Jews were intensely in-
volved in the resulting boom in trade

and haulage, as well as in lending. No
longer restricted by the regulations of
the guilds and chambers of commerce,
and experienced as they were in trad-
ing, they made full use of the new
opportunities offered by trade and
transport, and played an important
role in the business life of Frankfurt.

By the end of the nineteenth century,
major Jewish retail outlets and depart-
ment stores were an important feature
of the Zeil and the Rossmarkt in the
centre of Frankfurt. Jewish bankers
and brokers also took a high profile in
the banking community, and there
were Jewish owners of major industrial
companies.

55 per cent of the Jews earned their
living in trade, most of them small to
medium-sized commodity traders and
retailers. An increasing number of Jews
entered the employment of large trad-
ing companies, specialist outlets and
banks. Industry remained a less impor-
tant employer, in terms of the overall
number of Jewish employees, with only
18 per cent. The percentage of Jewish
lawyers and physicians, on the other
hand, was relatively high.

The Jews regarded the path they had followed in Germany as a path of upward social mobility and integration in bourgeois society. During the Franco-Prussian war, they demonstrated their patriotism. Jewish soldiers were particularly proud of the fact that the King of Prussia respected their religious laws and customs during the war, allowing them to celebrate the Shabbat and granting them leave on their holy days. Many who did not learn of this in time celebrated Yom Kippur on the field of war.

During World War I, too, when many Jews eagerly volunteered for service, their religious customs were respected. Rabbis held patriotic speeches at home and on the field of war, and prayed for German victory. This path towards integration was suddenly cut off when the war ministry accommodated the country's increasingly anti-Semitic mood by maintaining that there was 'Jewish skiving' and by calling for a 'statistical record of the military service of German Jews.'

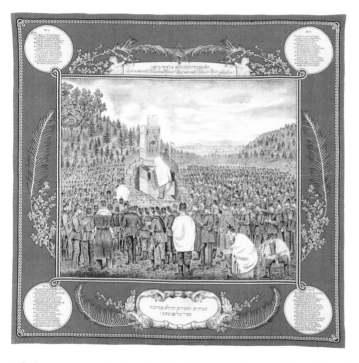

Cloth commemorating the 1870 Yom Kippur service near Metz during the Franco-Prussian war
Cotton, 65.5 cm high, 68.5 cm wide
JMF 87-2
At the centre the religious service is being performed with an improvised Torah Ark. The worshippers are in uniform and some are wearing the tallit or prayer shawl. The motto in Hebrew and German under the Star of David reads "Do we not all have one father, did not one God create us all?" In the four corners are verses of a hymn by Rabbi Ludwig Philippson, ending "Uplifted by faith, emboldened by duty, ready for the fray, they stand and do not waver."

Video installation
Four short films about the contribution made by Jewish citizens of Frankfurt in the fields of politics, science, business and the arts

Jews soon made outstanding achievements in other fields as well as commerce. In the city council, they were involved in all the political parties, and there were Jewish members of parliament of different parties, such as Leopold Sonnemann and Adolf Sabor, in the Reichstag. Henriette Fürth was one of the first women to become a member of the city parliament. In 1925, Ludwig Landmann became Frankfurt's first Jewish mayor.

Frankfurt Jews were represented in the arts and cultural life of the city as actors, singers, painters and journalists.

They were an important force in avant-garde and conservative circles alike and did not generally emphasize their Jewish identity.

Jewish foundations and patrons played an important role in the negotiations to found a university in Frankfurt in 1914. It was proposed that it should take the legal form of a foundation so that Jews would not be subjected to the Prussian administrative regulations that would stand in the way of a professorship.

Questions of Identity

As long as the Jews had to live in the Judengasse, they lived according to the rules and regulations of the ghetto. The political and social changes wrought by the Enlightenment had had a far-reaching influence on Jewish religious practice and on the attitude of the individual towards the Jewish community as a whole. Many Jews had called since the early nineteenth century for a modernization of the religious service and a more liberal approach to practising their faith. Liberal principles such as personal freedom, individuality and rationality were accorded greater importance than the traditions that had been binding in the days of the ghetto.

Participation in business life and gradual integration often led to conflicts between observance of religious laws such as the keeping of the Shabbat and the Christian-influenced everyday life and work.

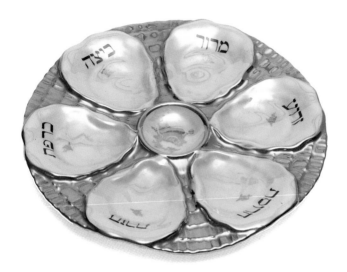

Seder plate for Passover
Plate with six sections in the style of an oyster plate. The inscriptions on each section specify the required symbolic foods; a lamb is depicted in the centre.
Karlsbad, late 19th/early 20th century
Gilded porcelain, 25 cm diameter
JMF 87-241

The extent to which Jewish identity had become separate from Jewish tradition is reflected in a number of household objects of the nineteenth and twentieth centuries.

A particularly distinctive example of this is the seder plate shown here, which an enterprising businessman sold in the spa town of Karlsbad. He simply added the Hebrew terms for the various symbolic Passover foods to an ordinary oyster plate, apparently not realizing that oysters cannot be eaten according to Jewish dietary laws. It may be assumed that the plate was displayed as a souvenir and was not actually used at Passover.

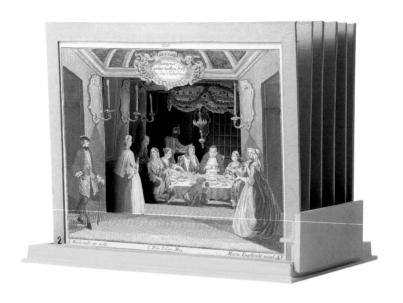

Tableau depicting the Feast of Tabernacles
First half of the 19th century
Based on a work by the Augsburg copperplate engraver Martin Engelbrecht
(1684–1756)
20 cm high, 25 cm wide, 18 cm deep
JMF 85-3

The seven panels shown here present different scenes of upper middle-class life. The third panel shows a family at a festive meal. The outer panel shows several tabernacles, though these look very different from the simple wooden structures used by German Jews for the festival of Sukkot.

Sukkot, also known as the Feast of Tabernacles, recalls the years spent in the wilderness after the Exodus from Egypt. 'Tabernacles' or booths in the form of temporary shelters are built on the balcony or in the garden, and meals are eaten there during the festival.

From the early 19th century onwards, tableaux of this kind became popular gifts for such occasions as a birthday, bar mitzvah or wedding, and usually integrated Jewish festivals and rituals into fashionable non-Jewish portrayals.

Different degrees of interest in religious practice triggered serious conflict in the larger Jewish community, with the result that different religious forms emerged. In some cities, Orthodox Jews separated from the community and founded a community of their own. This also happened in Frankfurt, where, in 1876, Orthodox Jews split away from the community with Rabbi Samson Raphael Hirsch to found the Israelite Religious Community (IRG: Israelitische Religionsgemeinschaft), which was to gain considerable importance. The IRG had its own synagogue (initially on Schützenstrasse, and later on Friedberger Anlage), two schools and a number of social and cultural facilities. Within the Jewish community itself, there were two tendencies – a liberal grouping with a synagogue on Börnestrasse (the former Judengasse) which was instrumental in shaping the Philanthropin school, and a conservative grouping with a synagogue on Börneplatz. Both groups ran a number of cultural social institutions.

The synagogue on Börneplatz, consecrated in 1882, was the synagogue of the conservative members of the community. Like the other synagogues, it was set ablaze on 10 November 1938 and in 1939 the city council ordered its demolition. The precious religious objects, most of them donated by members of the community, were stolen. The few that came to light again after 1945 have been returned to the present-day Jewish community.

Torah shield of the Börneplatz synagogue
Donated by Abraham and Recha Arnsberg on the bar mitzvah of their son Paul, according to the Hebrew inscription.
Frankfurt, 1913, silver, 37 cm high, 24 cm wide
On loan from the Jewish Community of Frankfurt am Main

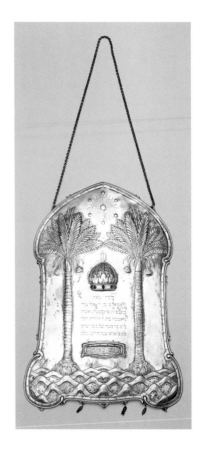

Advertisement for Tomor margarine
This margarine, based on almond milk, was acceptable to not strictly observant households as kosher.
Paper, 29.5 cm by 19.5 cm
JMF B 86/702

Orthodox and conservative Jews continued to observe religious regulations and dietary laws. Keeping a kosher household was a fundamental requirement.

Jewish newspapers ran many advertisements for kosher businesses and mail order companies. The shops and businesses were supervised by Frankfurt rabbis.

Anti-Semitism

Anti-Jewish attitudes were constantly in evidence during the process of emancipation of the Jews in Frankfurt and elsewhere in Germany, making it a difficult process fraught with conflict. The introduction of equal rights for Jews did not put an end to the animosity, which had become a component part of the social fabric, involving religious, nationalist, anti-capitalist and anti-democratic elements. The last phase of achieving legal equality for Jews, between 1869 and 1918, was overshadowed by increasing anti-Semitism aimed at the exclusion of Jews from German society. It grew even uglier in the form of racial anti-Semitism directed at all Jews, including converts to Christianity, on the grounds that they constituted an inferior yet dangerous 'Semitic race.' In the struggle between races, the 'Germanic race' embodied by the German people was called upon to free itself from 'non-Germanic' rule – including by violence against the 'alien race.'

Although the first mass anti-Semitic movement had little impact on Frankfurt, it is presented here because it was nevertheless an important factor in precipitating the rapid and radical exclusion of the Jews after 1933. In the era of the Weimar Republic, posters were displayed claiming a 'international Jewish conspiracy' against Germany and calling for resistance against 'Jewish hegemony.'

Anti-Semitism is documented in a continuous band that runs from the time of Jewish Emancipation to the days of National Socialism

Beer mug
Earthenware, *c.* 1910
Signed Joh. Korzilius, purveyor to the
court, Cologne-Ehrenfeld
23 cm high, 11.3 cm diameter
JMF 89-98

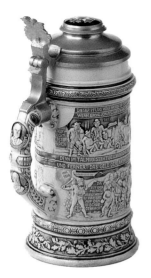

The bas-relief images show Jews 'mil-
king' peasants and craftsmen. Below
is a portrayal of the Jews being driven
out of Germany when 'der deutsche
Michel' (a proverbial simple German)
awakes.

The handle bears bust portraits of
the well-known anti-Semitic court
preachers Adolf Stoecker and D. A.
König.

The Frankfurt hotel Kölner Hof,
which barred Jews and prided itself
on being a 'Jew-free establishment'
served beer in mugs inscribed with the
words 'Kauft nicht bei Juden' (Don't
buy from Jews). Leaflets, postcards,
posters, calendars, pins, caricatures
and, of course, books, were used to
spread anti-Semitic feelings.

Individuals in the Weimar Republic

Assimilation and Identity

In 1925, there were 30,000 Jews living in Frankfurt. They accounted for 6.3 per cent of the population. Their political leanings, cultural interests, occupations and religious views were so diverse and individual that it is not possible to make generalizations about Jews in the Weimar Republic. This diversity is illustrated by a display of photographs of famous people and unknown individuals. They include social worker and feminist Bertha Pappenheim, an Orthodox woman; the German-nationalist Arthur von Weinberg; the painter Jakob Nussbaum; a class of girls at the Orthodox Samson Raphael Hirsch School; Alwin Kronacher, who was an influential figure in the arts and culture of Frankfurt, and the fencer Helene Meyer, who won a gold medal for Germany at the 1936 Olympics.

Portrait of Alfred Flechtheim
Bronze sculpture by Rudolf Belling,
1927
18 cm high, base 12 cm diameter
JMF 91-30

Alfred Flechtheim (1878–1937) was
an art dealer in Berlin, Frankfurt and
Düsseldorf. In 1933, he emigrated to
Paris, then to London, where he died
in 1937.

The artist Rudolf Belling
(1886–1972) was among those la-
belled by the Nazis as 'degenerate.'
He emigrated to Istanbul in 1937.

The events of World War I and the
1918 revolution, the founding of a
democratic German state with many
integrative possibilities, and the in-
creasingly aggressive forms taken by
anti-Semitism prompted an unexpect-
edly broad-based diversity of reactions
among Jews in respect of their Jewish
identity.

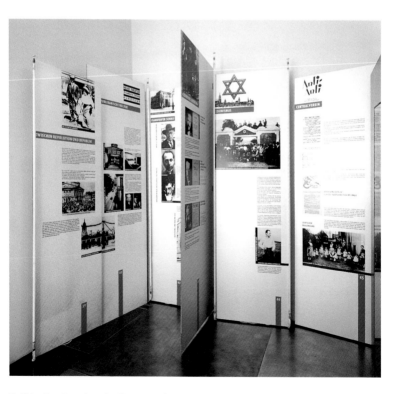

Political, cultural and religious achievements in the Weimar Republic

For many, personal integration as respected citizens brought with it an urge to contribute towards the development of an emancipated society. Others began to turn to their Jewish roots and either embraced the notion of an independent Jewish nation (Zionism) or became members of the Centralverein deutscher Staatsbürger jüdischen Glaubens (Central Association of German Citizens of Jewish Faith) who defended equal rights for Jews in the face of anti-Semitism, and at the same time advocated a secular Jewish nation or companionship of the same destiny.

Nehemia Anton Nobel
Conservative community rabbi from 1910–22
Photo JMF

The cultural Zionism of Martin Buber, Franz Rosenzweig (1886–1929) and Nehemia A. Nobel (1871–1922), which propounded the revitalization of the Jewish spirit on the basis of ancient sources and traditions within a modern society, exerted an enormous fascination, especially on the youth. In Frankfurt, they founded the Free Jewish College (Freies Jüdisches Lehrhaus). Rabbi Nobel was a charismatic figure whose lectures and sermons enthralled all who heard them.

Martin Buber
(1878 Vienna–1965 Jerusalem)
A socialist and religious philosopher, Martin Buber taught at the Freies Jüdisches Lehrhaus in Frankfurt from 1922 and was also an honorary professor at the University of Frankfurt. From 1916–38 he lived at Heppenheim an der Bergstrasse. He emigrated to Palestine in 1938.
Photo JMF

Persecution and Self-assertion

From 1933 onwards, in a climate of violence, many laws and ordinances were passed aimed at excluding German citizens who were Jews either in terms of their religious faith or according to the definitions of the race laws drawn up by Hitler. It was as though they had been caged.

The Weimar Republic, wracked by crises yet full of dreams, proved to be a period of transition towards National Socialism. The transfer of power to the Nazis and the collaboration of the populace in excluding and expelling their fellow citizens was the same in Frankfurt as it was in other German cities: it happened quickly and with little resistance.

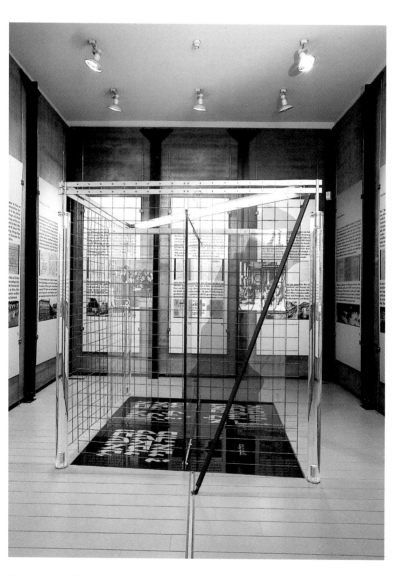

National Socialism: outcasts and prisoners

Collage of passport, surgery sign and textile printed with the yellow star
Photograph, originals JMF

Forced to take the additional middle-name of Sara or Israel, and with a capital 'J' stamped in their passports from the end of 1938 onwards, Jews no longer enjoyed freedom of movement.

As part of the drive to 'exclude Jews from the German economy' Jewish physicians were no longer allowed to practise, though some were ordered to keep their surgeries open for Jewish patients.

In September 1941, Jews were ordered to wear the yellow star inscribed with the word 'Jude' in public and closed areas. With that, they were publicly stigmatized and surrendered to arbitrary action.

Metalwork department of the training workshop on Fischerfeldstrasse
Photo JMF

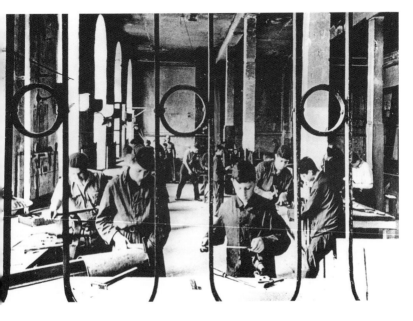

The Anlernwerkstatt (Training Workshop) was an institution that trained young people in skilled jobs, such as carpentry or gardening, which might serve them well on emigrating to Palestine or the USA. It is just one example of the many institutions created by the Jewish community to help its members. From 1933 onwards, the Jews had to be self-reliant. When exclusion and persecution began, most Jews were unprepared for it. Only a few resolved to resist actively.

The Jewish community organized preparation for emigration, including retraining, language courses, advice and advertising for emigration to Palestine, social and financial support, job-finding and loans. It also set up communal kitchens and ran cultural activities such as concerts, plays and film screenings, lectures and exhibitions, and issued public statements. All associations and events were subject to National Socialist control.

The Prisoners
Bronze sculpture by Ursula Liebrucks, 1988
36 cm high, 77 cm wide, 6 cm deep; JMF 92-1

Deportations began in October 1941. Between 1941 and 1944, at least 11,000 Jews were deported from Frankfurt. So far it has not been possible to ascertain exactly how many Frankfurt Jews were murdered, since many Frankfurt citizens were deported from other German towns and above all from occupied countries such as Holland and France. What is more, there is no record of the Polish Jews living in Frankfurt who had already been expelled in October 1938 and later deported. Most of the Jews were deported to work camps operating according to the principle of 'Destruction through Work.' From such camps, there was some news. Other transports brought Jews to places where they were shot immediately. Nor do we know the exact number of the few surviving Frankfurt Jews.

Survivors of
Bergen-Belsen
concentration
camp liberated
1945
Beth Hatefut-
soth
Tel Aviv

Life after 1945

The exhibition section headed Life after 1945 is based on the reading rooms in the camps for Jewish survivors where some 250,000 people waited to leave Europe between the end of the war and the founding of the Federal Republic of Germany. News of family members and political developments, especially in Eastern Europe and the Middle East, was among the most important factors in the immediate post-war period. The overwhelming majority of the survivors fled from the new Soviet sphere of influence in Eastern Europe to the Western zones of the allied occupying forces and emigrated from there to the USA, Palestine and other countries. The camps, most of them in the American zone, were supplied and managed by the UN. The people in the camps used the time they spent waiting there to prepare for a new life in a new country.

As early as the end of April 1945, a municipal facility was set up in Frankfurt for Jewish survivors, and with the return of the last community rabbi from Theresienstadt in July of the same year, a synagogue community was established. This community joined with the committee of Polish Jews set up by Eastern European refugees in Frankfurt, and in 1949 the Frankfurt Jewish community that still exists today was founded.

The chronicle of the Displaced Persons camp at Zeilsheim near Frankfurt, facsimiles of newspapers in Yiddish, the first year's issues of the Frankfurt community newspaper and a number of photo albums and other documents give an insight into the situation in the early post-war years.

The historical film excerpt *Let My People Go* gives an impression of the struggle to found a Jewish state in Palestine.

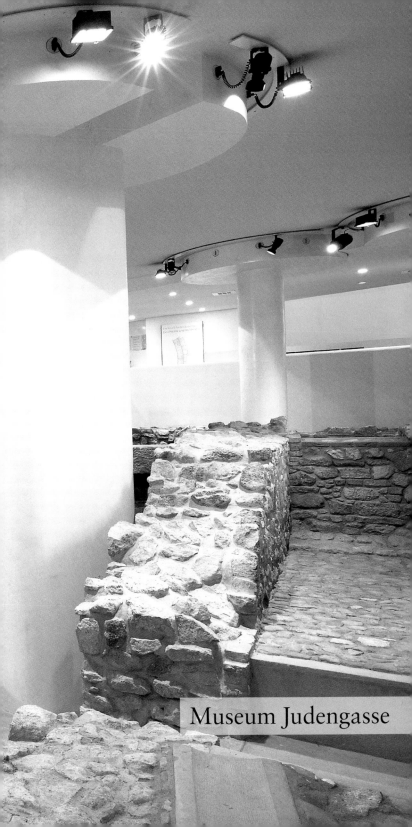

Museum Judengasse

The focal point of the annexe to the Jewish Museum at Börneplatz is the excavation of the archaeological remains of the Judengasse (Jewish alley). This includes the foundation walls of five houses, two ritual baths, two wells and a canal. Most of the remains date from the eighteenth century, though some date from the fifteenth century. Around the ruins there is an exhibition elucidating the history of the ghetto, everyday life in the houses of the Judengasse, the history of Börneplatz up to the present day and the archaeology of the Judengasse.

An information data bank contains details about the Judengasse and the people who lived there. The Börnegalerie shows small temporary exhibitions on art history and cultural history relating to Jewish life past and present. There is also a data bank here containing the names and biographies of the Frankfurt Jews known to have been deported and murdered.

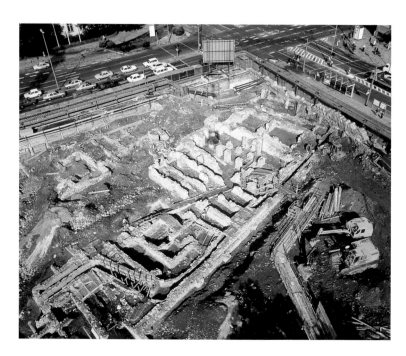

Börneplatz excavations, Frankfurt, 1987

In 1987, building work in preparation for the new customer service centre of the municipal utilities company uncovered the southern section of the Judengasse. It was originally planned that the findings should be documented and then cleared. However, popular protest provoked months of debate about the fate of the ruins and how best to treat these witnesses of Jewish history. The city of Frankfurt then decided to retain part of the excavations. They were in fact removed, but were painstakingly reconstructed on the original site over a period of several years once the customer service centre had been completed.

pp. 86–87: **Remains of the Frankfurt ghetto on display in the Museum Judengasse**

Model of the district today, showing the site of the former ghetto (suitable for the blind and partially sighted)

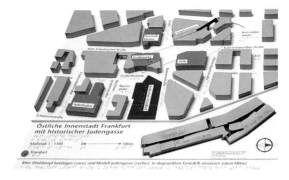

The Frankfurt Ghetto – History and Architecture

The Frankfurt ghetto known as the Judengasse is difficult to trace in the urban fabric of Frankfurt today. The construction of Kurt-Schumacher-Strasse and Berliner Strasse after the war completely changed the structure of the eastern part of the inner city.

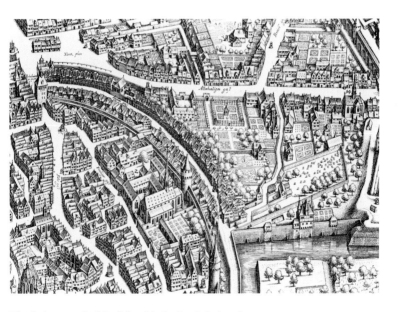

The Judengasse in Matthäus Merian's 1628 city plan
Historisches Museum Frankfurt am Main

Today, all that remains of the former Judengasse is a fragment of the Staufen dynasty city wall that had formed the ghetto boundary since the fifteenth century, a memorial plaque for the main synagogue destroyed in 1938 and the archaeological excavations in the museum.

The Merian city plan of 1628 shows the state of the Judengasse following the population explosion of the sixteenth century. The proportions are not quite precise – in particular, the streets are too wide in this depiction. Nevertheless, the crowded conditions of the Judengasse are clearly evident.

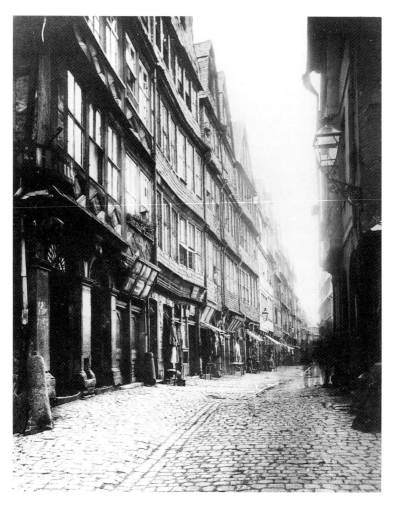

The Judengasse, Frankfurt, _c._ 1860
Historisches Museum Frankfurt am Main

Built between 1460 and 1462, a population of about 200 lived there in some 20 houses until the early sixteenth century.

By 1600, the population of the ghetto had grown to more than 2,700 persons in 195 houses. As the actual site was not extended, the Judengasse developed into the cramped and gloomy place that is described in the travelogues of the eighteenth century. Matthäus Merian's city plan of 1628 shows the gates situated at the north, west and south of the Judengasse,

which were closed at night and on Christian holy days. Originally, the Frankfurt Jews lived in the area to the south of the cathedral, until the city council decreed that they sell their synagogues and houses and move to the specially-built ghetto.

The photograph on this page, taken around 1860, is one of the earliest known photographs of the Judengasse. It is remarkable that so few people are to be seen on the street in this densely populated ghetto. It was some 300 yards long and up to six

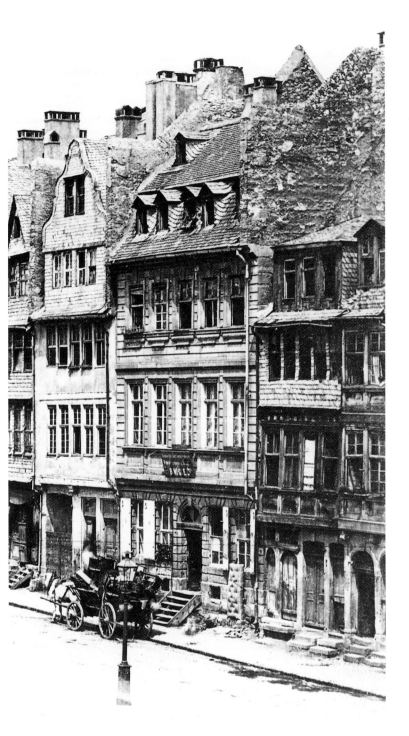

Eastern section of the Judengasse, Frankfurt, *c.* 1880
Historisches Museum Frankfurt am Main

yards wide in places. It was bounded on either side by a closed row of two-storey half-timbered buildings, many of which have been extended upwards by a further two or even three floors. Some of the houses were built in the space between the ghetto walls and the houses directly lining the street. The photograph on page 91 was taken during the demolition of the Juden-gasse between 1874 and 1887. The western row of houses has already been demolished, leaving a view of the remaining eastern row. We can recognize the five houses whose cellar walls can now be seen in the museum. From left to right, they are the buildings known as 'Warmes Bad' or 'Klause' with a public well in the facade; and the houses known as 'Sperber,' 'Roter Widder,' 'Weisser Widder.' The 'Warmes Bad' took its name from the neighbouring 'Kaltes Bad' – that is to say from the mikveh – and was one of the larger houses in the Judengasse, being some four yards in width. From about 1684 onwards it was the home of the so-called 'Klausrabbi,' who ran the yeshivah or talmudic college. The 'Steinernes House' was the only entirely stone-built house in the Judengasse, and was erected after 1717 by Isaac Nathan Oppenheimer, imperial court factor from Vienna. The three adjoin-ing houses which share a single roof-truss are typical of the houses to be found in the Judengasse in the seven-teenth and eighteenth centuries. As a rule they were no more than three yards wide and were the homes of the Jewish middle and lower classes.

Remains of the old mikveh (1462–1711)

The Houses and their Inhabitants – Everyday Life in the Judengasse

On the site of the 'Steinernes House,' before the great fire that swept through the Judengasse in 1711, there was a house for community officials such as the Hazzan and the community servant. A mikveh was installed in the cellar dating back to the earliest phase of the ghetto between 1460

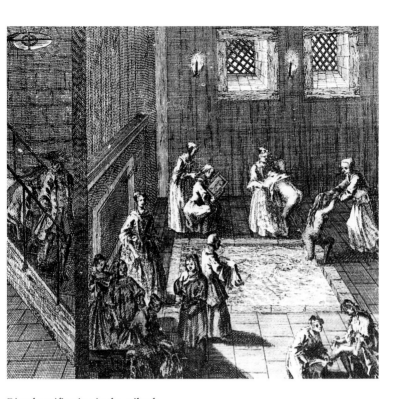

Ritual purification in the mikveh
Copperplate engraving in Johann Christoph Georg Bodenschatz' *Aufrichtig Teutsch Redender Hebräer*, Frankfurt and Leipzig 1756, Part 4, Plate VII
JMF 620

and 1462. Six steps remain, leading down into the ritual bath. When the old mikveh was abandoned and filled in, one of the load-bearing pillars of the 'Steinernes House' was actually set where the bath had been. The bath was filled from groundwater. The common designation 'Kaltes Bad' (Cold Bath) in reference to the mikveh is to be taken quite literally.

In accordance with Mosaic law, women must purify themselves ritually after childbirth or menstruation. This requires a bath that is large enough for an adult to be completely immersed. It must be filled with 'living water,' gathered from rainwater or a groundwater spring. The copperplate engraving from the eighteenth century illustrating a protestant theologist's book on Judaism elucidates the various phases of the ritual bath in the mikveh. A woman enters the mikveh accompanied by a servant, loosens her hair, undresses completely and then submerges herself in the water.

The bath was also used to ritually purify dishes or cooking utensils. Since Jewish dietary laws forbid the mixing of dairy products and meat, and requires that separate dishes be used for both, dishes and cooking utensils must also be immersed in 'living water' before they are used.

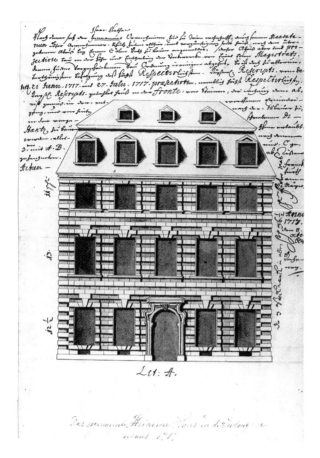

Facade of the Steinernes Haus (Stone House)
From the documents submitted for planning permission, 1717
Historisches Museum Frankfurt am Main

The crowded housing and cramped conditions of the Judengasse led to a number of major fires in the eighteenth century. In 1711, all the houses in the Judengasse burned down. The site on which the mikveh had stood was sold by the community to Isaac Nathan Oppenheimer, imperial court factor from Vienna, who wanted to build a prestigious baroque town house here for his visits to Frankfurt during trade fairs and other such occasions. However, the plans he submitted were not approved by the city council, which found 'the fine frontispiece and other eye-catching ornamentation far too magnificent.' Only on the repeated intervention of the emperor and after a number of amendments to the plan was the house finally built. In the years that followed, the house was used by the Kann family, who held a leading position in the community and who were related to the court factor's family. In 1717, a mikveh was installed in the cellar of the Steinernes House, which was probably used by the people living in the house.

The older mikveh, which had been destroyed in 1711, had been intended for the use of everyone in the community and had for many years been the only mikveh in the Judengasse until a new one was installed at the synagogue

New mikveh in the Steinernes Haus (1717–1887)

in 1602. A spiral stairway leads from an antechamber in the cellar of the house to the bath filled with groundwater, some six yards below street level. The antechamber, which was probably heated, was used for undressing before descending to the mikveh.

The house that previously stood on the site of the Steinernes Haus was known as the Hochzeitshaus (Wedding House) and was used for festivities and celebrations. The copperplate engraving (below) from the book by Johann Jacob Schudt, rector of the Frankfurt grammar school, shows a veiled woman under the wedding canopy (huppah) being led through the Judengasse to the courtyard of the synagogue for the marriage ceremony. Jewish musicians lead the procession.

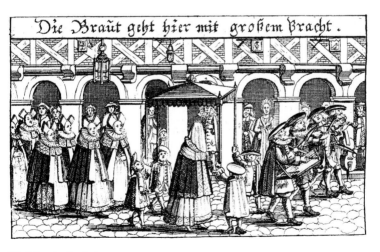

Wedding in the Judengasse
Copperplate engraving in Johann Jacob Schudt's *Jüdische Merckwürdigkeiten*, Frankfurt 1717, Part 4/3, p. 74; JMF 3616

The women and men are dressed in the characteristic garb of Frankfurt Jews in the period around 1700. Above the doors we can see the signs with the pictorial designations of the house names. The foundation walls of the three houses known as Sperber (Sparrowhawk), Roter Widder (Red Ram) and Weisser Widder (White Ram) stretched from the lane almost right up to the eastern wall of the ghetto, which is recognizable in the photograph below by its red mortar. Though only three yards wide, the houses were some 20 yards long, thus making full use of the little space available. Moreover, the small courtyards to the rear of the houses often contained sheds and toilets. The many niches in the walls are the remnants of wall cupboards which were closed with metal

or wooden doors and served to store precious items. They indicate that the houses were not only used as living quarters, but also contained shops and storerooms. The majority of the Jews had been involved in trade since the seventeenth century, the previously predominant business of money-lending having become a secondary occupation.

The architectural history of these three houses is typical of the heavily-developed Judengasse. In the early 16th century, the houses known as Rad (Wheel) and Widder (Ram) were the first to be built on the 200-square-meter site next to the mikveh. The Sperber (Sparrowhawk) was added in 1580. In 1590, the Widder was divided up and the resulting pair of new houses were named Roter Widder

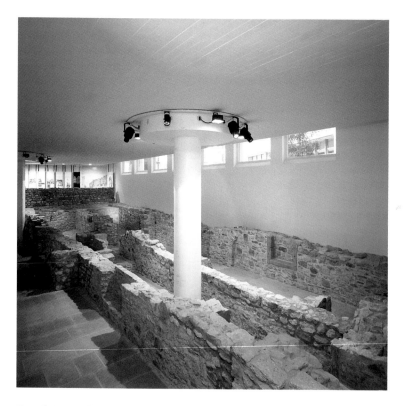

Foundation walls of the houses 'Sperber,' 'Roter Widder,' 'Weisser Widder' and eastern ghetto wall

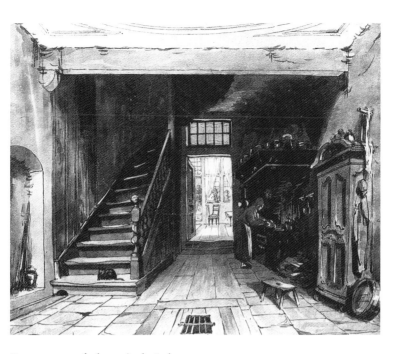

Entrance area of a house in the Judengasse.
Photograph after a painting by Otto Lindheimer, 1884 (original lost)

(Red Ram) and Weisser Widder(White Ram). The house known as Rad (Wheel) was abandoned towards the end of the seventeenth century and the other three were rebuilt after the Great Fire of 1711.

Official municipal records indicate that members of the middle and lower classes occupied these three houses around 1700. They traded in linen or sold bread and brandies. A schoolmaster in the Roter Widder taught reading and writing in Hebrew. As teachers were generally poorly paid, he undoubtedly ranked among the lower classes of the ghetto. Other inhabitants of these houses worked as casual labourers or were simply described as poor. All in all, there were ten families registered as living in these three houses in 1703, the Sperber being the most crowded with 14 persons sharing 80 square metres.

The painting by Otto Lindheimer (above) was made shortly after the Judengasse was finally demolished.

It is one of the few portrayals of an interior in the Judengasse. As in most of the houses, the kitchen, including the stove, is located in the stairwell due to lack of space. The houses tended to be very dark, the only source of light being windows facing the narrow Judengasse or the small backyards. A trapdoor in the floor leads to the cellar.

Behind the houses, a sewer ran from north to south along the ghetto wall and into the River Main. It was about 1.8 m deep and 1.5 m wide. A similar channel was situated behind the row of houses on the west side. Above the channel, small toilet cubicles had been installed.

Drain by the eastern ghetto wall

Bedroom of the house in which Ludwig Börne was born
Historisches Museum Frankfurt am Main

This was in fact a fairly modern facility in comparison to other parts of old Frankfurt, where the houses only had septic tanks that had to be emptied at regular intervals. The sewage channels of the Judengasse were swept out once a year by the city hangman and his assistants, for a fee. Originally, the channels were not covered, and caused a stench in the summer. Yet for many years the city council refused to allow the Jewish community to cover them.

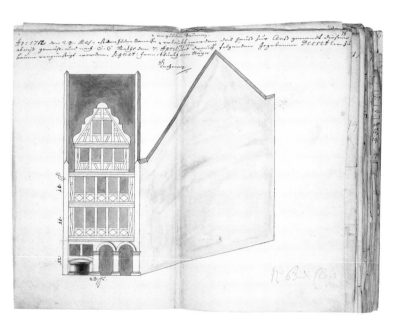

Construction sketch of the Warm Bath and well, 1712
Institut für Stadtgeschichte Frankfurt am Main

The construction drawing of 1712 shows the facade of the *Warmes Bad* or Klause, and a side view of the house. Such drawings had to be submitted to the city officials after the Great Fire of 1711 in order to obtain building permission. The actual building work was then carried out by Christian builders.

In the stone-built ground-level storey, a well was installed that could be accessed from the street.

It was one of five public wells in the Judengasse providing drinking water for the population. Only a few houses such as the Steinernes Haus had their own private well in the cellar.

For a nominal fee, water-carriers brought the water from the wells to the houses. They were among the poorest of all the inhabitants in the Judengasse, for they had no permanent right of residence and had to earn their living by casual labour. It is estimated that some 80 per cent of the Jewish population in the German Reich at the end of the eighteenth century belonged to this impoverished class. Often tolerated only briefly, they moved from place to place.

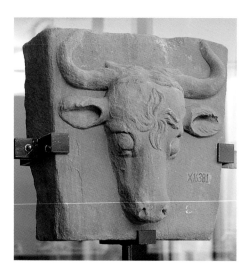

Stone with the sign of the slaughterhouse, after 1711
41 cm high, 41 cm wide, 20 cm deep
Historisches Museum Frankfurt am Main X 16381

Signs with pictorial representations of the house names jutted out into the street over the houses in the Judengasse. After 1711, these were replaced by stones built in over the doors. When the Judengasse was demolished, some of these stones were placed in the Historisches Museum.

The ox-head designated the slaughterhouse at the southern end of the Judengasse. One of the few skilled occupations open to Jews was the slaughtering of animals and processing of meat. As this had to be performed according to the dietary laws set forth in the Bible and the Talmud, requiring special training and rabbinic supervision, the council permitted the Jewish community to establish a slaughterhouse in the sixteenth century and to slaughter animals there for their own use.

The names of the houses were also displayed on the grilles installed above or beside the house doors for ventilation purposes. Many families eventually took their names from these house names. The most famous example being the Rothschild family, which built the house Zum Roten Schild (At the Red Sign) in the sixteenth century, and retained the name when they moved elsewhere. The house signs featured in women's jewellery, Hannukah candle holders and kiddush cups. This indicates the importance of owning a house, or part of a house, to the families in the Judengasse. It was one of the conditions by which Jews could obtain permanent rights of residence in Frankfurt.

The house signs also feature on many of the gravestones in the adjacent Old Jewish Cemetery. Once again, this is a reflection of how important the house names were to the identity of the people who lived there. The cemetery was established before 1272 and was in use until 1828. Around 1900, more than 6,000 gravestones were counted there, two-thirds of which were later destroyed by the National Socialists. The Frankfurt cemetery is one of the oldest and most important Jewish cemeteries in Europe.

Metal grill with the sign of the 'Rote Traube' house and stone sign of the
'Moor' and 'Flask' houses, after 1711
57 cm high, 127 cm wide, 10 cm deep;
28 cm high, 43 cm wide, 49 cm deep
Historisches Museum Frankfurt am Main X 312, X 7839

Tombstones with house signs

From the Judengasse to Börneplatz

The model shows the Judengasse and its surroundings in the period around 1860. We can recognize the Judengasse, the adjacent Jewish Cemetery and the marketplace known as Judenmarkt at the southern end of the street. Immediately to the south-east is the Fischerfeld district which was developed in neo-classicist style from 1800 onwards.

The northern section of the Judengasse was also rebuilt in this style, having been destroyed in the bombardment of Frankfurt by French troops in 1796. As many families then had to seek alternative accommodation in other parts of the town, forced confinement in the ghetto became impracticable after 1796 and was officially repealed in 1811. Nevertheless, the population of the Judengasse was still almost entirely Jewish in the first half of the nineteenth century. Gradually, however, many families began to move away, initially to the neighbouring Fischerfeld district. Many Jewish institutions such as synagogues, hospitals, schools and also shops, were established in the east end of Frankfurt, which remained the centre of Jewish life until the National Socialist period. Living conditions in the Judengasse itself were regarded as so appalling that almost all the houses were demolished between 1874 and 1887 and the area redeveloped. Only the home of the Rothschild family remained as a museum.

With the demolition of the last houses, the Judengasse was renamed Börnestrasse and the Judenmarkt was renamed Börneplatz. Three years earlier, one of Frankfurt's main synagogues had been built here. It was intended for use by the conservative members of the community who did not accept the liturgical reforms that had been introduced by the majority, but who nevertheless did not wish to leave the old community and join the new Orthodox community. The first rabbi appointed to the Börneplatz synagogue was Marcus Horovitz.

Like all the other Frankfurt synagogues, the Börneplatz synagogue was destroyed on 10 November 1938.

Model of the Judengasse and surrounding area, *c.* 1860

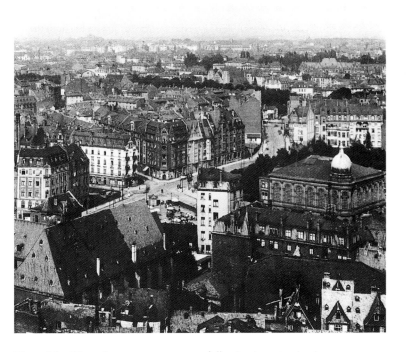

View of the Börneplatz synagogue, 1912, following its extension in 1901
Institut für Stadtgeschichte Frankfurt am Main

What was left of it was finally demolished in the following months at the cost of the Jewish community. From 1987–1990 the remains of the synagogue were uncovered during excavation work on Börneplatz. The few remaining fragments are presented in a small special exhibition in the Museum Judengasse.

For a long time after the war, Börneplatz posed something of a problem for the town planners. A wholesale flower market was installed here, and a petrol station, and part of the square was used as a car park. All that recalled the destruction of the Börneplatz synagogue was a small plaque installed in 1946. It was not until 1978 that the name Börneplatz was reinstated, having been changed to Dominikanerplatz by the National Socialist city council in 1933.

Above: **Archaeology of the Judengasse**
Below: **Relics from the Börneplatz synagogue**

In the late 1970s, efforts were made to find a historically appropriate form for the square. In 1985, however, the city council decided that the new customer service centre of the municipal utilities company, Stadtwerke Frankfurt, should be built there. While digging out the foundations, the remains of the Judengasse were un-covered, triggering a debate that culminated in the site being occupied by those lobbying for the archaeological remains to be fully retained.

Archaeology of the Judengasse

The excavations carried out at Börneplatz from 1987–88 give a new insight into the architectural history of the ghetto and everyday life there. The most interesting finds, together with construction plans and historical illustrations, document the excavation. The exhibition mounted in collaboration with the Frankfurt Museum of Prehistory and Early History – Archaeological Museum charts the history of the site since the Roman era, the construction of the Judengasse and features of everyday life such as water supply, food storage, cooking and even children's games.

Neuer Börneplatz Memorial

In 1996, a memorial to Frankfurt's third Jewish community, destroyed by the National Socialists, was unveiled on Neuer Börneplatz right beside the Museum Judengasse. At its centre are 11,000 blocks set into the cemetery wall, inscribed with the names of Frankfurt Jews who were deported and murdered. In the Museum Judengasse, a data bank provides biographies and photographs of the murdered Jews. The painstaking research involved is likely to continue for a number of years.

The memorial, the Old Jewish Cemetery and the Museum Judengasse form a historic ensemble at Neuer Börneplatz that permits visitors to study the history of the Jews of Frankfurt in depth.

The cemetery wall bears the names of deported and murdered Frankfurt Jews

pp. 106–107: **Neuer Börneplatz memorial, 1996, detail of Battonnstrasse**

Jewish Museum Facilities

Documentation

The documentation section of the museum collects and archives material pertaining to German-Jewish history.

This also includes a picture archive with photographs of individuals, ritual objects and community facilities throughout the German-speaking region.

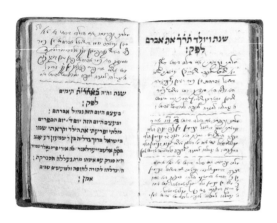

Mohel book (register of circumcision) from Linnich, Rhineland, 1822–65, manuscript
JMF 86/68
Bernhard Brilling Collection

Ludwig Meidner Archive

The archive contains works from the estate of the Expressionist Ludwig Meidner (1884 Bernstadt–1966 Darmstadt) and comprises oil paintings, works on paper, sketchbooks, drawings, prints and works by fellow artists. The archive holds the copyright to Meidner's oeuvre. Moreover, works from the estates of Else Meidner (1901 Berlin – 1987 London), Kurt Levy (1911 Bonn–1987 Cologne) and Arie Goral (1909 Rheda, Westphalia–1996 Hamburg) are also held here. The archive collects work by Jewish and exiled artists from the period 1933–45.

Ludwig Meidner
Self-Portrait, 1922
Oil on cardboard, 99 x 72 cm
JMF, Ludwig Meidner Archive

Library

The museum library is open to staff and visitors alike. It is a reference library only (not a lending library), with more than 20,000 volumes on the subject of Judaism and the history of the Jews in Germany and Central Europe as well as films relating to the individual exhibition sections.

The library

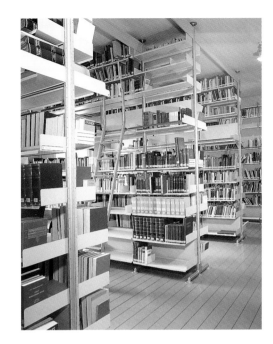

The Museum Café

The 'Buch–Café im Jüdischen Museum' is a meeting place for visitors, staff and passersby. As a rule, it stays open one hour longer than the museum itself. The café serves vegetarian snacks and a selection of drinks. The adjacent bookshop, which stocks books on the history and culture of the Jews and holds interesting readings, accepts book requests and orders.

The café

Index of Proper Names

Index

Sources of illustrations